M000105421

LOOK CLOSER, DRAW BETTER

To my family: Mom, Dad, Michael, Kris, and Anna,
you have never failed to encourage, believing in me always.

And to my love, Rick, who helped me find my wings,
who walks the path beside me, who is my ever-steadfast soft place to fall.

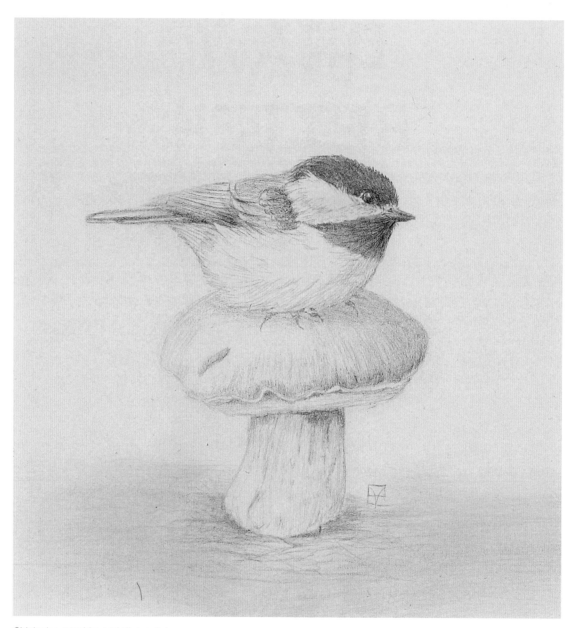

Chickadee, graphite and silverpoint

LOOK CLOSER, DRAW BETTER

Expert Techniques
for Realistic Drawing

———

KATERI EWING

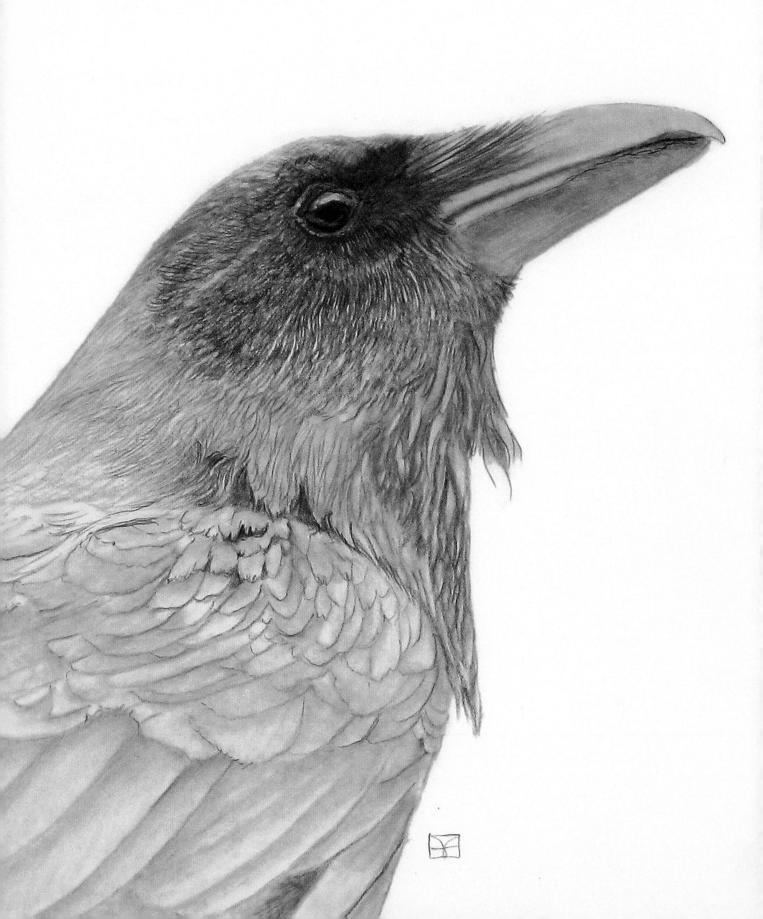

CONTENTS

Opposite: American Crow, graphite

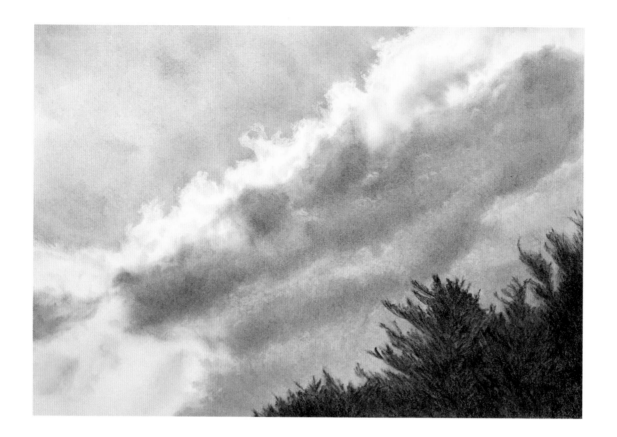

INTRODUCTION

If I had to choose one lesson that I could pass along to other artists, there is only one real choice: the importance and joy of learning to see. I have been absolutely amazed and enchanted—as perhaps you have, too—to discover what happens to our artwork when we truly learn not just what, but how, to see. If I had to explain the core of what I have taken into my heart, as an artist, it is my belief that if we pay close enough attention, we can discover immense beauty in the most ordinary subjects of our daily lives.

On the front page of every sketchbook I own, I inscribe this phrase: *Remember the Luminous Particular.* I keep those words in my mind while I work, as guiding lights and guardian spirits. For me, the luminous particular is the spark of individual presence that all things—animate or inanimate; large or small; animal, vegetable, or mineral—have, if we are observant, inviting, and open to that presence. It is my constant work to discover how to truly see and then illuminate the soul, the essence, the spark—the poetry—of my subjects. My purpose as an artist is to always seek that presence.

Thank you for joining me as we learn to see, and welcome.

Kateri Ewing

Above: Untitled, graphite and charcoal *Opposite: Found Leaves,* graphite

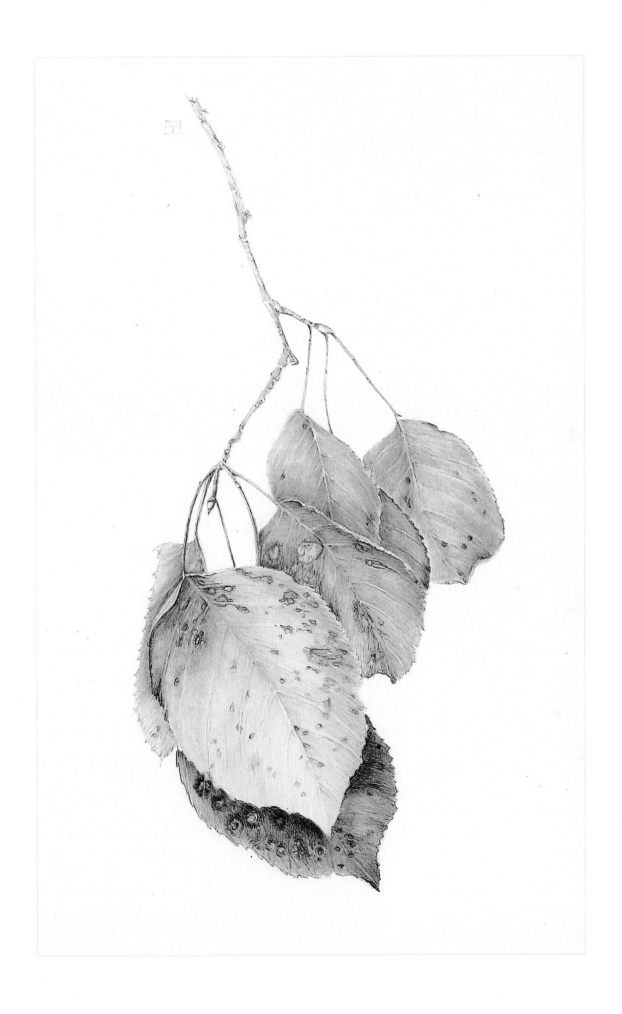

THE HOW AND THE WHY

I like to imagine that each person who reads this book is sitting across the studio table from me, eager to draw, to learn, and to share ideas. After we settle in and begin to get some marks down on paper, I'll ask you, "How did you come to drawing? Why are you here and what is it you hope to learn?" Throughout our time together in this book, we'll explore those two most important elements of drawing: the *how* and the *why*.

You'll learn the *how*—the mark making techniques using graphite, charcoal, pen and ink, and watercolor. Through them, I hope you will discover a series of different languages that you can use to portray, on paper, your own unique way of seeing—the *how* of learning to see your subjects when drawing in a realistic style.

And you'll discover the *why*. The *why* is what allows each of us to imagine things in our mind's eye differently: No two human beings see, imagine, or process the world around them in the same way. It is also true that we come to our art with very personal reasons for why we want to create in the first place. An emotional response is necessary in our work, as well as our connection to the reasons that we choose our subjects. Why do we choose specific subjects for our drawings? What is it about them that makes our heart sing? This is the *why* that makes art.

Over the years, I have taught many people the *how*. I teach them all the same information, the same approach, the same mark making techniques, and the very same brushstrokes, but when I give a group of five students the same subject to draw, every single one of them is vastly different. This is something

to celebrate! In this book, you will not find techniques requiring measuring or even perspective. Instead, you will learn how to see your subject's form in shape, light, and shadow and how to capture the things *you* notice about what makes it unique. You will learn how to bring detail and quiet presence to your realistic drawings in a way that makes the ordinary extraordinary. Yes, I will teach you how to use the medium of your choice to mark down what you see, but mostly, I will teach you how to see through your own artist's eyes.

My hope is that you leave our time together with skills that you can practice and refine, but also with the desire to nurture your *why* and begin to really see your subjects and what makes them special to you. My job is to teach you how to capture, on paper, your own unique way of seeing the subjects that you find meaningful.

There isn't a moment I spend drawing or painting when I am not immensely grateful for the opportunity to learn more about the world around me and then to create something lasting and beautiful from it. With each drawing or painting, I hope to discover, and then reveal, the intricate cycles of nature, the luminous particulars that I have come to notice in natural objects, be it the spark in a bird's eye, a decaying leaf, a broken acorn, or the wash of light and shadow as they play over a meadow, pond, or stand of trees. It is the desire to urge myself and others to pause and to look a bit more closely, to discover the extraordinary in the ordinary, that stokes my creative fire each and every day. I wish the same for you.

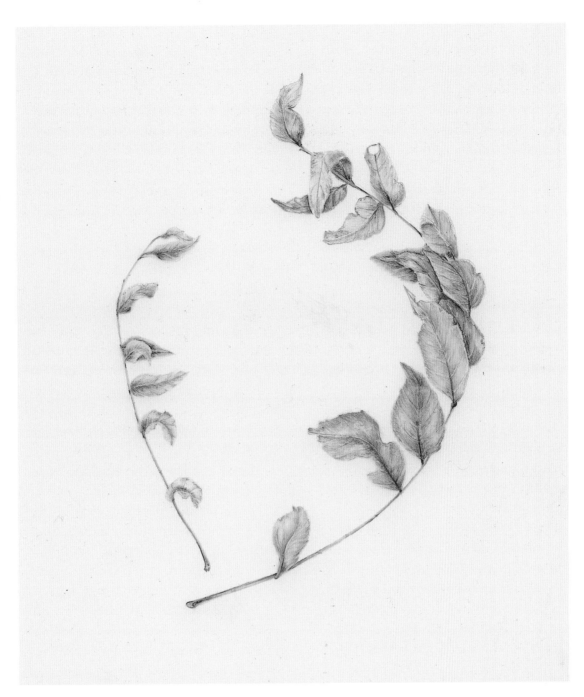

Privet, graphite

THE HOW AND THE WHY

9

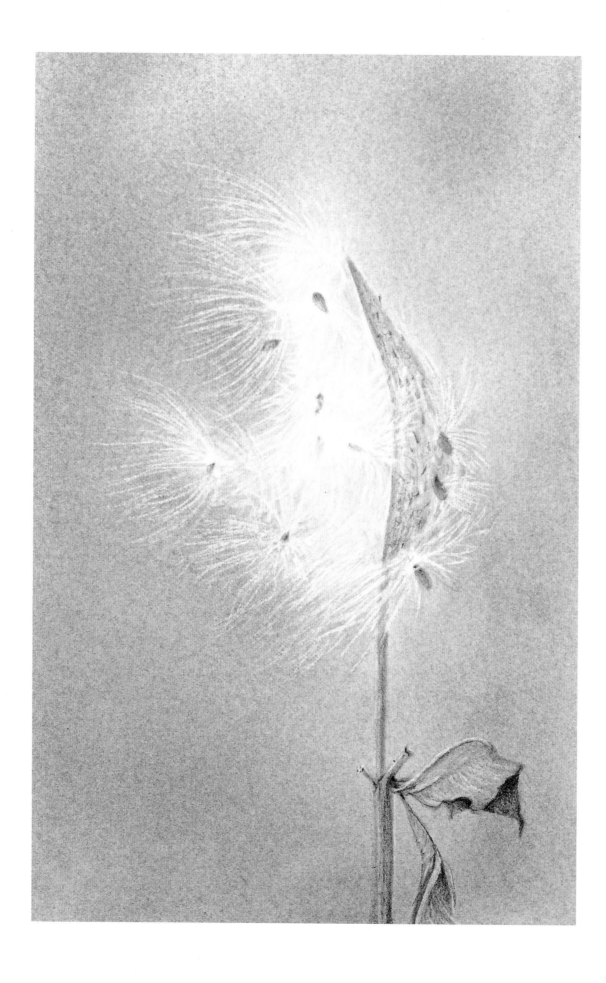

LEARNING TO SEE

As artists desiring to draw our subjects in a realistic way, our eyes are our most valuable tool. It might sound strange, but when we are drawing, our brains are always trying to trick us. What our brains know and what our eyes truly see are quite different. Our aim should be to rely more on our eyes and learn to see the world around us in a different way; we want to train our eyes to see like an artist. Drawing in a realistic style is slow work. It requires that we take pause and truly notice things like shadow and light, the subtle turns and transitions between them, and the relationship of our subject to the environment that surrounds it.

Let's try a little experiment. Close your eyes and imagine that you are looking at a coffee mug sitting on your kitchen table. Take a few moments to really see it in your mind's eye. Pick up a pencil and a sheet of paper and draw a line to depict the flat surface of the table. Then, draw a simple outline sketch of your imaginary mug resting on that surface. Don't fret over details, just a quick drawing that shows your mug positioned on the surface of your table.

If you were to draw that mug without looking it at, you might draw a straight line depicting where the bottom of the mug rests on the flat surface of the table. Eight out of ten people will draw the bottom of their mug with a straight line. Our brains are clever and know that the table is flat, that the bottom of the mug is flat, but drawing that straight line is not going to produce the illusion of roundness that we need to realistically portray a 3-D object, like a mug, on paper.

Now, find an actual mug and place it on the table in front of you. Notice the line depicting where the bottom of the mug meets the table surface. What you will see is a curve. Our brains know that the mug is flat and the table is flat, but our eyes see something different. Our eyes see roundness. What we need to capture in our drawings is the roundness of that mug. We do that with a combination of line and values of light and dark, as our eyes really see them.

The 19th-century artist and writer, John Ruskin, wrote, "I believe that the sight is a more important thing than the drawing. I would rather teach drawing that my pupils may learn to love nature, than teach the looking at nature that they may learn to draw." It's true, learning to draw is the best way to learn how to truly see, and learning to see is the best way to learn how to draw. They can't exist without one another, if our aim is to draw our subjects in a realistic way. The beauty of it is, not only will your drawings improve, but you will begin to appreciate the world around you in a more profound way. You will acquire the artist's eye.

Opposite: Leita's Milkweed, graphite

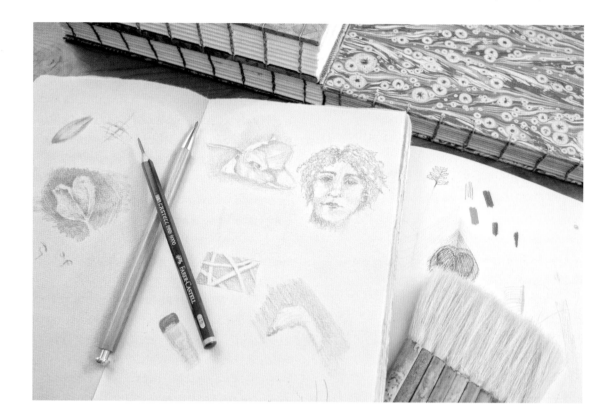

THE DAILY SKETCHBOOK HABIT

Imagine for a moment that you decide you want to learn how to play the piano. You make the investment in a keyboard, buy some instructional books, some sheet music, and you sit down to begin to play. Unless you are a musical genius, it would be immediately obvious that you won't get very far without some lessons and plenty of daily practice. I'm sure if you asked seasoned musicians how often they practiced their basic scales in the beginning years, they would all say, "Far more than I ever thought I would need to."

Drawing is no different. Whenever we learn a new skill, it requires discipline and the awareness that we need to leave perfectionism and the expectation of lofty performances behind for a while and attend to the most basic drills and exercises. Musicians play their scales; artists open their sketchbooks and draw—every day. I can promise you that no matter what your skill level, once you commit to a daily sketchbook habit, you will see a vast improvement in the quality of your work.

I've seen it in myself, and in my students, over and over again.

I have kept my own daily sketchbooks for years and not only have they helped me become a better draftsman, but they have also given me a record of my journey as an artist. They have allowed me a safe space to try out new ideas and techniques, to fail and make a mess, and even to create something beautiful. My daily sketchbook habit has given me confidence, and it has also helped me to refine my observational skills. It has helped me learn how to see.

I suggest that you keep one sketchbook for everything, not too big and not too small. The perfect size is about 9 × 12 inches (23 × 30 cm) with a stitched binding that lies flat. There are so many great brands, but my favorite is the Strathmore 500 Mixed Media Journal, perfect for all mediums, both wet and dry. My other favorites are my handmade sketchbooks created for me by a friend who is a book artist. I use both types equally and for everything

related to my work as an artist. I begin each book with the date I start it and leave room for the date I when finish. In my books, I work out ideas, try new things, make lists, jot down quotes that inspire me—just about anything at all. It is also where I do my daily drawing exercises, and I suggest it's where you do yours, as well.

The Daily Exercises

Just like a musician who practices their scales, the artist needs to practice connecting their eyes and their hand together. The following exercises are the perfect way to strengthen the eye/hand connection and require only a few minutes each day.

BLIND CONTOUR DRAWINGS

The blind contour drawing is the single most useful exercise I know of to train our eyes and our hands to work together. I do them daily, even for two minutes while I eat my breakfast. Choose a subject that you can see well; it's even better if it is something you can set right in front of you. Now, position your paper to your right if you are right-handed and to your left if you're left-handed. Take any drawing tool and set your eyes upon a starting point of the contour, or outline, of your subject. The aim is to begin and end at the same place.

Without looking at your paper, move your eyes clockwise around the outline of your subject, simply drawing that outline with no detail whatsoever. The trick is to not look at your drawing, but keep your focus on your subject, moving your eyes and your pencil or pen at a very slow pace. The reason we do this exercise is not to get an exact likeness of our subject but to train our eyes and our hands to slow down and work at the same speed.

If you end up with something that resembles your subject, congratulations! But I hardly ever do.

What I have noticed is that after doing this exercise daily for several weeks, my ability to slow down and really see my subject has improved immensely, and my quick sketches have become even quicker, as I do not have to look back and forth between my drawing and my subject as often as I did before. If you only do one daily exercise, make it this one. Vary your subjects, even the complexity of them, and your eyes and hands will become a team that will serve you well.

ARM-EXTENDED GESTURE SKETCHES

A gesture drawing helps us see our subjects in terms of energy, form, and value. Think of keeping these to as little as five seconds

and then a longer practice of fewer than five minutes. Tape a piece of paper to your easel or to the wall and hold your pencil loosely in your fingers, arm extended full length, so that the tip of the pencil rests on the paper. By extending our arm and not gripping the pencil tightly, we lose some of our control. This makes it easier to avoid putting in details and to focus instead on keeping our lines fluid and expressive, the main intention of a gestural sketch.

Position your subject a short distance from where you have taped your paper and begin to make sweeping, sketchy lines depicting the general direction of the main components of your subject. Then, begin to use these scribble marks to create the darkest areas of your subject. Avoid creating an outline. Instead, use these swift marks to create form, light, and shadow, filling out the space that creates your subject.

Doing this exercise before beginning a more serious drawing helps us to visualize the values and the form of the subject. It also helps to create a sense of natural energy in our work, rather than painstakingly trying to draw the outline first. Gestural sketches can also be done by taping several pencils of different ranges of hardness together or by taping a pencil to the end of a dowel, further extending the reach of your arm.

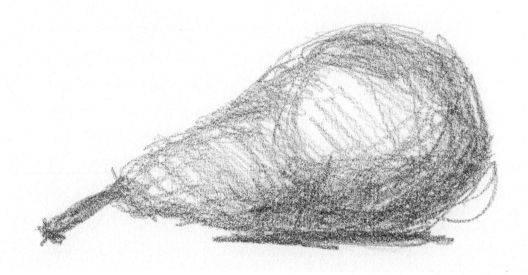

BLINDFOLDED SELF-PORTRAITS

I added the blindfolded self-portrait to my morning sketchbook habit about two years ago, and it has greatly improved my sense of texture and form. By removing my outward vision, I enhance my inner vision and have learned to trust my ability to sense contour in my subjects. By choosing to use self-portraiture as my focus for this exercise, I always have a subject at the ready and can see different results of the same subject each day.

You can either use a blindfold or simply close your eyes, if you promise not to open them. Open your sketchbook and place your pencil on the paper to mark the top of your head; then, close your eyes and lift your other hand to begin to feel its way around your face. Create marks on the paper that depict the way each part of your face feels to your fingertips. For example, my eyebrows feel like tiny upward dashes, while the way my eyelids curve feels smoother. Where I feel the contours of my face dip in, I create softer, darker marks that depict shadow.

Work your way around your entire face, meeting back up where you started at the top of your head. Then, set your pencil down and open your eyes. Often, I am amazed at how this exercise reveals my current mood. A few of these drawings have been so remarkable that I've framed them. Over time, I've learned so much about intuitive mark making and hope that you will try this exercise as often as possible.

The most important thing is to show up to your sketchbook for at least fifteen minutes each day. Make it a habit, as vital as brushing your teeth. Take the sketchbook with you everywhere, vary your subjects, do quick sketches, and work out compositions and new ideas. Use your imagination to create drawings from memory. Try these simple exercises I've shared. But most of all, just show up. Your drawings will reap the benefits in no time.

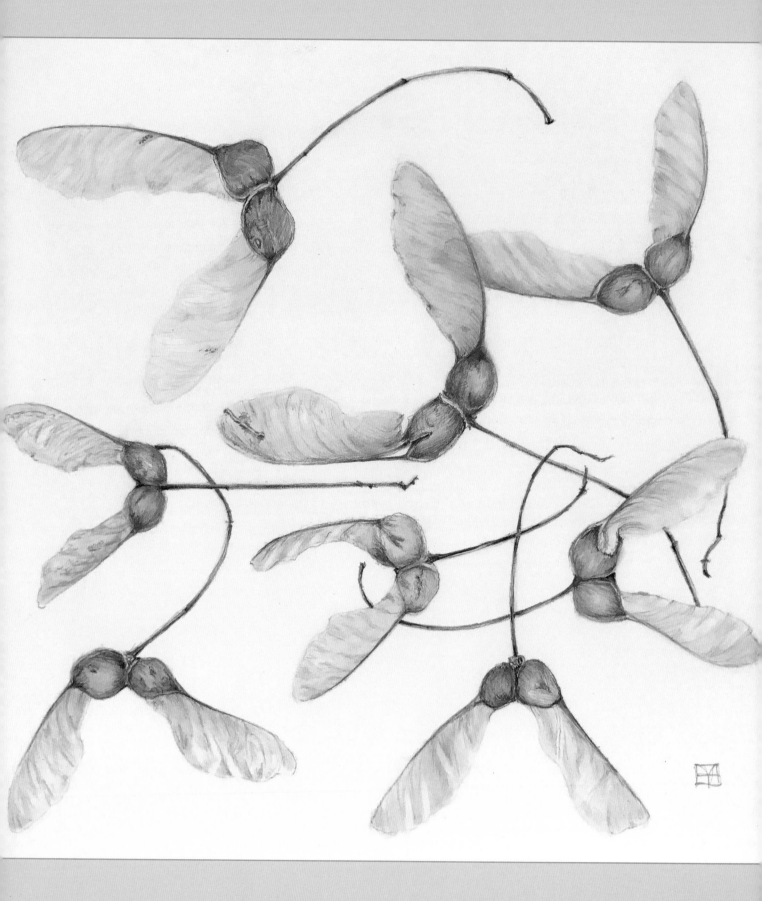

GRAPHITE

In considering the techniques for realistic drawings, graphite will be our foundation. Almost every project in this book, except for the lessons on charcoal, will rely on the use of graphite in the form of a wood-encased pencil that we will sharpen to a very fine point. There are so many other forms of graphite to explore, from the silky, deep-toned powdered graphite to the watercolor-like effects of water-soluble graphite. All have their place, and I hope that in time you will experiment with each of them.

Opposite: Maple Seeds, graphite

Graphite Drawing

Of all the mediums I have worked with over my career, graphite is my favorite. There is something so subtle and delicate about its silvery line, the way it can be so crisp, and yet also smudge under my fingertips to impart a sense of softness and delicacy that I have not been able to achieve with any other tool. I turn to graphite when my subject calls for a quietness and delicate rendering. It is also the foundation for all of my work in ink and in watercolor. I consider graphite the foundational medium for all forms of art.

Tools and Materials

The supplies we need for drawing are simple and few. I like to stress quality over quantity. If we keep things simple, we can learn to focus more on technique. We grow so accustomed to our chosen supplies that using them becomes intuitive.

I've tried many types of drawing materials over the years, from so many different manufacturers. In the end, I've found that quality does matter. Excellent materials make our job easier and are a pleasure to use. I find myself purchasing fewer supplies and wasting less when I select quality products. Whether using graphite, charcoal, ink, or watercolor, there are really only a few items that are true necessities. Those that I am suggesting are widely available at many art supply stores and online.

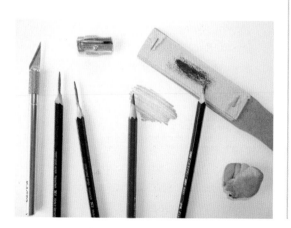

PENCILS

Graphite is a gray, crystalline form of carbon with a metallic sheen, whose name comes from the Greek *graphein* (to write). Most of us begin to use the ordinary No. 2 pencil in our early childhood, so the humble pencil can seem like a familiar tool. The great American artist Andrew Wyeth said he used only a cheap No. 2 pencil and whatever paper he could find. I have done the same, and while it is possible to achieve great results with the most ordinary pencils and paper, I have found that artist-grade pencils in a few degrees of hardness have made a difference in my work.

Pencils come in sets of varying degrees of lead hardness, ranging from 10H, the hardest, to 10B, the softest. These sets can be fun to experiment with, but you really don't need all of them. You can achieve a full-value spectrum using just four pencils: 4H, HB, 2B, and 6B.

WHAT IS LEAD HARDNESS?

Artist pencils are labeled with a series of numbers and letters. H stands for hardness, and B stands for softness, or blackness. The higher the number that accompanies the H, the harder the lead, so the scratchier and paler the line will be and the harder it will be to erase and blend. The higher the number

in the B spectrum, the softer or darker the line will be and the easier it is to blend. A 4H gives a pale silvery-gray tone, whereas the 6B gives a rich, charcoal-gray tone. HB lead is right in the middle and is similar to a No. 2 pencil. 2B is a bit darker. For the most part, we will be using pencils with an HB and a 2B lead hardness.

Using the appropriate lead hardness can greatly improve the look of our drawings. The best reason for using a variety of levels of lead hardness is to be able to achieve a lighter and a darker line with a very delicate touch. When we draw, we want to use the lightest pressure possible, so that we do not embed the graphite in the paper, develop a sheen by pressing too hard, or score the paper with a very sharp lead. By using a delicate touch, we also preserve the textural quality of the paper: This can be an important part of our drawing, as we'll cover in the section on paper choice. To keep my mark making delicate, I imagine that the tip of my pencil is a feather and I am simply tickling the paper with it.

When selecting pencils, choose an artist-grade quality with a wood casing made from cedar or other hard wood. Specialty pencils such as woodless, mechanical, or water-soluble are great fun to explore, but we will not be using them for the techniques covered in this book. Remember to keep it simple: Quality over quantity.

PAPER

The look of drawings can change dramatically, depending on the surface we choose. If you have spent any time in an art supply store, you'll know that the array of choices for paper can be dizzying. There are four things I like to consider when choosing a paper for my drawings:

1. **Fiber content.** 100% cotton is my choice for fine drawings on paper. It can be expensive to use for practice, but that is why we have a sketchbook for daily exercises and for exploring and fine-tuning our subjects and ideas.

2. **Texture.** The finish of paper matters. Drawing papers come in varying degrees of smoothness, from the glossy plate-finish; to the ribbed, laid texture; to fine-toothed vellum finish; hot-pressed watercolor paper; and even the rougher texture of a cold-pressed watercolor paper. All of these have their place. For my purposes, I choose a drawing paper with a fine tooth such as Stonehenge made by Legion Paper or a hot-pressed watercolor paper such as Fabriano Artistico or Arches. The finish has just enough texture to hold the graphite, but is smooth enough to achieve the finest details. For our lessons together, I suggest a fine-toothed paper such as Stonehenge or a Bristol Vellum. For our sketchbook work, choose a drawing paper sketchbook that has a slight tooth, not totally smooth. This texture is often referred to as a *vellum finish*.

3. **Durability.** A good-quality drawing paper stands up to many layers of graphite application and erasing without pilling or tearing. Inexpensive printer or notebook paper won't stand up to the techniques required to achieve realistic drawings and will make your job more difficult. Find a paper that can withstand the layering and erasing of graphite. Buying a paper that is at least 90 lb (165 gsm) weight is a great place to start.

4. **Color.** Drawing papers come in many colors, but the most common are white and cream. The hue of our paper does affect the mood and outcome of our drawing. White is more stark and modern and is best for drawings that will be reproduced in print. Cream has a softer appearance and a more traditional look. Stonehenge paper comes in a variety of white and cream shades. You can select what appeals to you most. My only advice is to keep your paper color very light for the techniques we are exploring. I will be using Stonehenge White in 90 lb (165 gsm) for the graphite lessons in this book.

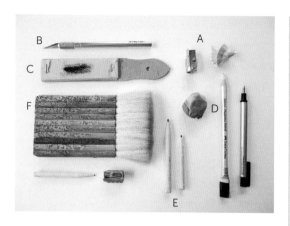

OTHER TOOLS FOR GRAPHITE DRAWING

While the choice of pencils and paper are the most important considerations, there are a few other tools we'll need to create successful realistic drawings. These are the materials I rely on for all of my graphite work on paper:

- **Pencil sharpener (A).** While a good-quality pencil sharpener is always handy to have, I use a craft knife (B) and sandpaper (C) to form a long, fine point on my pencils. The long, needle-sharp point allows me a greater range of motion in laying down large areas of graphite with the side of the pencil, and it allows me to use the needle-sharp tip for very fine details. Once you get used to this method of preparing your pencils, you'll wonder how you ever got along without it. If you are at all uncomfortable using a blade to sharpen your pencils, a good-quality, long-point pencil sharpener is a great substitute. Long-point pencil sharpeners are available at art supply stores and online.
- **Erasers (D).** I use two types of erasers for my graphite work: a kneaded eraser and a stick eraser that I can sharpen to a fine point. The kneaded eraser can be molded into many useful shapes and it is very gentle on the paper, leaving no eraser debris. It will last a long time if properly cared for. Each time I use it, I pull it apart and knead it to work the graphite into the eraser,

leaving a clean putty. I can also flatten it and press it onto the paper to remove large areas of highlights. Two stick erasers that I use are the Perfection 7508, unique to the Faber-Castell brand and available in wood casing that can be sharpened to a very fine point with a standard pencil sharpener, and the Tombow Mono Zero, 2.3 mm. These are perfect for removing very small areas of graphite with ease. While other brands of stick erasers are available, I have not had much luck in finding others that are easily sharpened to a fine point.

- **Tortillons (E).** These slender paper stumps are my go-to for softening lines and subtle blending. Also called blending stumps, they can purchased in bulk at any art supply store. The pointed tips are delicate and should not be pressed too hard. They are very inexpensive and should be replaced when the tip wears down. I save older blending stumps that have accumulated a layer of graphite to use as drawing tools when I need a softer, smudgier line.
- **Brush (F).** I use a Japanese hake brush to dust off my paper instead of using my fingers, which can leave behind an oily film and ruin a drawing in an instant. You can also use an old cosmetic brush, a feather, or a drafting brush. Just make sure it is soft and clean.
- **A carbon pencil.** I keep a carbon pencil handy for times when I need a very intense black. It is rare that I need it, but it's nice to have if the occasion occurs.
- **A word about easels.** Many artists enjoy using an easel for their work. I typically do not use an easel for drawing in a realistic style. I find that having my drawing paper flat on the table allows me more control. If you prefer to work upright on an easel, a table easel is a great and flexible choice for smaller works on paper. It truly is a personal preference.

Values in Graphite

Understanding the importance of value is fundamental to achieving realistic drawings in any medium. Value is defined as how light or dark something is, and it's used in drawing to depict light and shadow and to create the illusion of roundness for 3-D effects in our two-dimensional works on paper.

When using graphite, there are several ways to achieve different values in our drawings: pressure, using different lead hardness degrees, and creating layers.

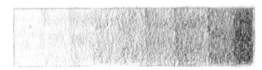

HB Example 1

Pressure: We can achieve different values using just one lead hardness. In Example 1, I used an HB pencil to create a value scale by switching from very light pressure to harder pressure. This is fine when we are making sketches and want the convenience of using only one pencil. The trouble comes when we use too much pressure. The graphite can become embedded in the paper, destroying the appearance of the paper's texture and creating unwanted shine.

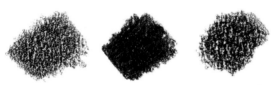

Example 2

Take a look at Example 2. I've made three swatches: a 6B pencil using layers to create a deep value without losing the texture of the paper; another using a 6B pencil with too much pressure, losing the texture and creating a shine; and another with a carbon pencil, which can achieve the deepest black values without creating shine or losing paper texture. I keep a carbon pencil in my tool box for times when I need that black tone, but do not want to lose the textural quality of the paper. When we use graphite heavily, it tends to get shiny. Instead of appearing darker, as we are intending, it creates a reflective finish that is undesirable for most realistic drawing techniques. Too much pressure with a harder pencil, such as a 4H, can create an impression on the paper's surface, which will also negatively affect the outcome of the drawing.

Using different levels of lead hardness and layering: In Example 3, I have created a value scale from the very lightest to the darkest tones that I can achieve by using light pressure with these four pencils. I began with a 4H, using the lightest touch possible, to fill in ¼ of the rectangle. I then used a second, light layer of 4H pencil beginning about ¼ of the way in, and then one more layer beginning about ½ of the way in, and again ¾ of the way in. Next, I used my HB lead to repeat the same four layers, moving across the value scale, and then repeated the activity using the 2B and the 6B pencils. I also created a value scale for each pencil using a single layer of hatching and then used cross-hatching in three directions to complete the full range of value for each pencil. It's really important to get a feel for the value scales of the pencils you are using. Try these exercises in your sketchbook several times and keep them as a handy reference for what your own pencils are capable of.

As you can see, we can achieve a wide range of value with just one pencil. Having a selection from 4H to 6B gives us even more possibilities and allows us to use the light touch that is so desirable in achieving realistic shading and textures in our drawings.

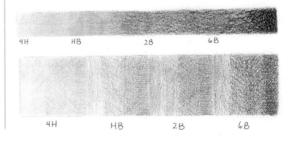

4H HB 2B 6B

4H HB 2B 6B

Graphite Project: A Single Pear

While doing daily sketchbook exercises is vital to our progress, diving into a project is the perfect way to learn and practice new skills and techniques. Completing a drawing project from start to finish reveals how it flows together, step by step. When learning new processes, it's important to keep subjects simple so that our focus can be on technique and not on trying to navigate a difficult composition.

Pears are my go-to subject for a first realistic drawing project. They are readily available, stay fresh and unchanged for quite a while, and have a fairly simple contour line, easily broken down into a circle and a triangle that anyone can draw. The skin of a pear can have some fascinating and varied markings that are just right for learning how to create the illusion of texture with graphite. Pears are also quite beautiful with elegant line, texture, and form.

For this project, I will work from a reference image that you can use, as well. Once you

Before we begin, I'd like to share a bit of advice I offer to all of my students. The first time we attempt a project, we're learning. The second time, we're practicing. By the third time, we're much more confident in the steps we need to complete for the best results. Then, we can relax and work with a better flow, which almost always results in a better drawing. I suggest you consider trying each of the projects in this book three times for the very best learning experience.

have completed your first drawing, I highly recommend using a real pear to repeat the process from a life study instead of relying on a photo. Photographs are perfect to help us flatten a 3-D image so that we can accurately see contour, shadow shapes, and highlights, but they can also fool our eyes when we're trying to see the more subtle details like texture. Our eyes see best when we are working from life.

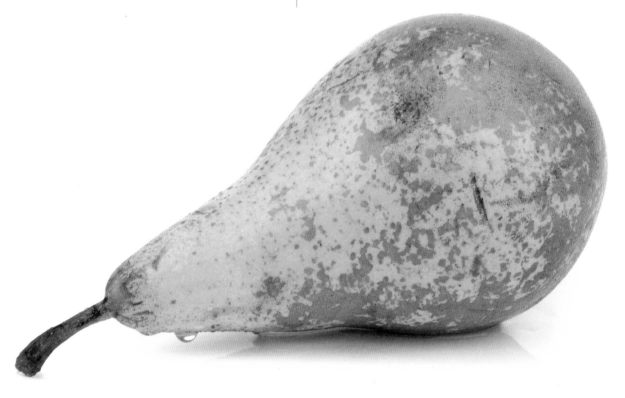

A single pear

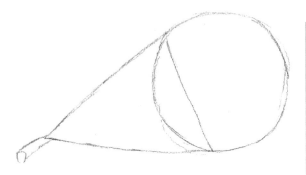

THE BIG PICTURE

No matter how simple or complex the subject, begin by finding the basic shapes that make up each element and then draw those shapes on the paper to establish the composition. The composition defines how our subject exists on the space created by the boundaries of our paper. Composition is a vast subject on its own, and many books have been written about it. If you are looking to understand composition better, I have listed some great references at the back of this book.

For this project, our subject, a pear, will be positioned a little off-center on the paper. This gives a relaxed effect and keeps things simple, so we can draw the viewer's attention to the fine details that we create. In most of my work, I rely on this kind of simplicity. My subject shines when there are no other elements to compete with it.

To begin, look closely at the way the subject is built of simple shapes. For our pear, it's fairly straightforward; it is constructed of a circle with an elongated triangle, narrowing to a fine point at the end of the stem. I do not rely on measuring, but on observation and comparison, and I typically draw to the same scale as my reference image or subject. If I am drawing from life, I keep my subject near my paper and will often set it on the paper to experiment with positioning. Once I've made that decision, I begin to draw the basic shapes.

Using an HB pencil, lightly sketch the circle and then the triangle, as close to the size of the reference image as possible. In every stage of a drawing, the eraser is our friend.

Use it. Make adjustments to the initial shapes until you are satisfied with the proportions and composition as compared to the reference.

When we begin our drawings in this way, we have an immediate picture of how our entire subject sits on the page. If I were to begin at one end of my subject and draw it carefully, adding in value and detail all at once, chances are that I would run out of room or end up with something out of scale or proportion. If I needed to make adjustments, I would have to begin again. Getting the big picture down first helps us avoid this disappointment.

REFINING THE OUTLINE

Now that the basic shapes, or big picture view, are down on the paper, begin to refine the pear's outline by carefully observing the difference between the shapes and the actual subject. In the example, I have made the final outline in blue. Notice how it differs from the shapes I drew first. Sometimes, the changes are quite simple, and other times, more dramatic. Really take your time and make sure your final outline is as close to your subject as possible. Once you are happy with it, use an eraser to clean up any extra lines that you no longer need.

▶ **Tip:** At this stage, if you've used an eraser quite a bit and it is noticeable, you can trace the outline and transfer it to a clean piece of drawing paper using graphite transfer paper. You can also place your outline underneath a clean piece of paper, tape them both to a window or a light box, and trace a new outline with an HB pencil on a clean sheet of paper.

Direction of Form

How we put graphite down when we're filling an outline with tone is very important. Notice the two leaves depicted below. On the left one, I simply filled in the outline, not paying any mind to the direction of my marks. On the one on the right, I followed something called *direction of form*, a way of closely observing a subject for the direction of its contours. When we pay attention to this, our drawing already has the suggestion of dimension and shape as we begin. Seeing direction of form in our subjects takes practice and close observation. Practice this using many ordinary, small subjects such as this walnut and piece of cork or small stones or dried leaves you might find on a walk. Once we are able to see the contour direction of our subjects, our drawings greatly improve.

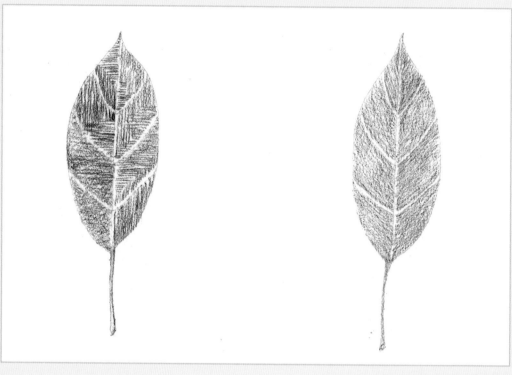

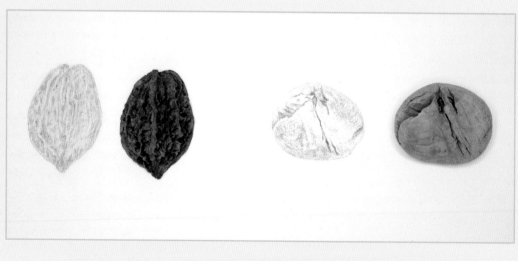

LOSING THE LINES

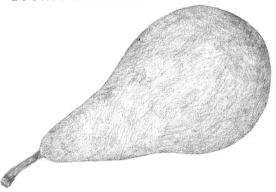

Now that the outline is complete, add a mid-tone layer of graphite to the entire form. For the pear, use an HB pencil to lightly fill in the outline by laying down graphite in the *direction of form* that you observe. This initial layer should be uniform and applied with light pressure. Barely graze the paper for a smooth application that allows the texture of paper to show through. If you accidentally go too heavy, you can press a kneaded eraser over the darker areas to gently lift some of the graphite. Again, this takes practice. Take this step slowly and try to get the smoothest application possible. The technique of creating a mid-tone layer in direction of form is one of the most important steps in creating realistic drawings.

REVEALING THE LIGHT AND ADDING SHADOW SHAPES

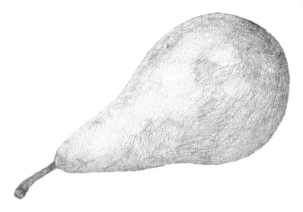

With the mid-tone layer in place, it is time to add contrast to the pear. The two qualities that create the illusion of roundness in realistic drawings are contrast between light and dark and the smooth transitions between them.

Carefully observe your reference for the lightest areas of value. These are the highlights reflected on the subject. Using the kneaded eraser, begin to lightly press it onto the areas of the mid-tone layer that you observe as the lightest in value. Remove the graphite slowly, a little at a time, until you have revealed the same amount of highlight as you have observed.

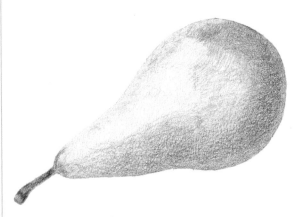

Now, with a 2B pencil, begin to lightly add in darker values where you see them on your reference image. Pay attention to the shapes that the darker values make. Re-create the same shapes in light layers until you have achieved a likeness to your reference. Never forget that the kneaded eraser can be used at any stage to fix any heaviness of hand or the wrong placement of graphite.

There are two important things to remember when adding the shadow shapes in this stage. First, use the softer 2B pencil at an angle to lightly graze the paper. Notice how, even though I am adding a darker value, the texture of the paper remains visible. Second, always consider the direction of form as you continue to apply your pencil strokes.

ADDING TEXTURE WITH GRAPHITE

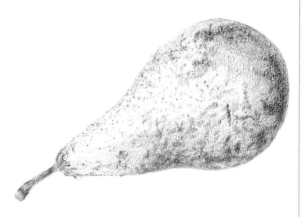

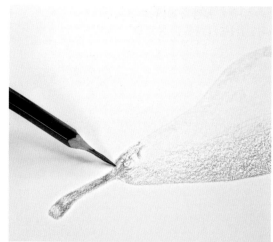

Now that the pear has a mid-tone layer, highlights, and basic shadow shapes, it's time to refine the contrast by adding textural marks. For this step, we will once again pay very close attention to our reference, noticing areas of different textures, lightness and darkness, and details specific to this pear.

When adding textural marks to drawings, we tap into our intuition to use the pencil as a way to imitate what nature has provided. In simplest terms, we draw what we see. We want to create the illusion of what our eyes notice and that is unique to our subject. The pear image that we are using has some very specific markings to capture in this phase of our drawing. Notice the subtle variations and blemishes in the patterning on the skin, the rough texture of the stem, and the tiny water droplet where the top of the pear meets the table it rests on. These are the nuances that make our subject unique and give our drawings presence and a story.

▶ **Tip:** A few things to remember: Keep your marks in the direction of form, as you see them on the subject. Keep the layers light, using different degrees of lead hardness to create lighter or darker values. Finally, remember that in this phase of the drawing, we are adding the surface details that we see. We will add more shading, shadows, and the finest details later.

Begin with an HB pencil for the areas of the lightest values. Starting near the stem, begin to use light marks depicting the surface textures and markings that you see on the pear. I think of this process as going over the subject with a fine-tooth comb, documenting everything that I see. Sometimes, we use the pencil to lightly shade; sometimes, we use hatching or even finely stippled dots. We are mimicking the marks of the pear on the paper with the tip of the pencil.

After you have completed the textural marks on the areas in highlight, switch to a 2B pencil to repeat the process in the darker shadow shapes. When this step is complete, your pear should appear about like the example shown. Remember, we all see things in our own way. The important thing is to mark down, lightly and in direction of form, exactly what you see, to the level of detail you wish to depict.

REVISITING VALUE AND ADDING THE FINE DETAILS

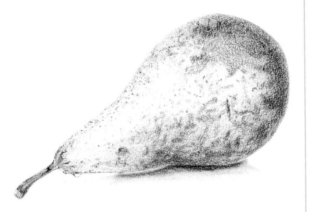

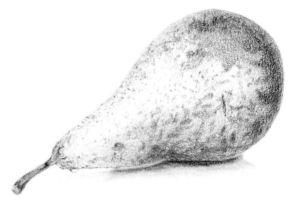

The next phase of the drawing focuses on making sure the highlights are light enough and that the shadow shapes are dark enough. I like to think of this as the dance between dark and light. Take a look at your drawing as compared to your reference. Where do you see more light in the drawing? If you need to lift graphite from a larger area, press the kneaded eraser on it lightly to reveal a small amount of light where needed. In a tight area, use the sharp tip of a stick eraser.

Next, take a look at where the reference might be darker in the shadow areas. Using a 2B pencil, refine those areas on the pear with a subtle layer of graphite, keeping your strokes even and soft. I tend to use small, circular motions with the lightest touch so that the texture of the paper remains.

Add in the cast shadow with the 2B pencil, paying close attention to where it meets the pear. Once the cast shadow is in place, use your tortillon or blending stump to softly smudge the graphite so that it becomes darker where appropriate and lighter the farther away it is from the pear. Look closely at your reference image and mimic the cast shadow that you see. Notice that there is a fine sliver of light where the pear meets the cast shadow. You can use a stick eraser to lighten this area, if necessary.

Once you are happy with the overall contrast of dark and light, begin to notice where you might need the very darkest values. These are often very small details, but adding them creates an impact on the realism of our drawings. Using a very sharp 6B pencil and light pressure, add a sheer layer of darkest graphite to where you see it in the reference, most likely a very small area toward the rounded bottom on the right of the pear and where the cast shadow meets the pear.

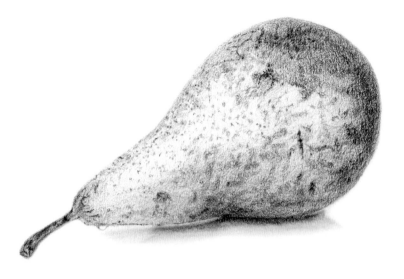

Last, take another close look to seek out the tiniest areas with the deepest dark details. Using the very tip of a sharp 6B pencil, add in these subtle details, paying close attention to the stem of the pear and to the textural markings.

The last step in our realistic pear drawing is to make sure the transitions are very smooth between dark and light. Using the 4H pencil as a blending tool, lightly smooth any areas between shadow and highlight that need to be more subtle. This isn't always necessary, depending on how lightly we have added our darks, but I find that I most often need to do a little smoothing between my brightest highlights as they transition into shadow. Notice how I used the 4H pencil to lightly enhance the center tone of the pear, to make the transition between dark and light more subtle.

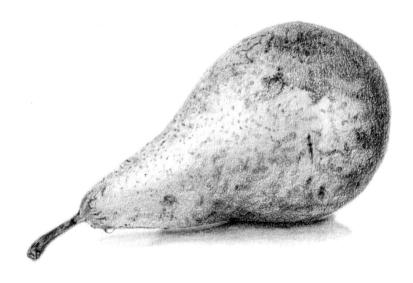

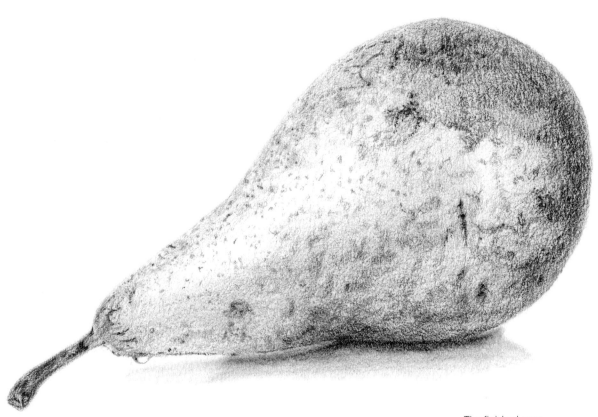

The finished pear

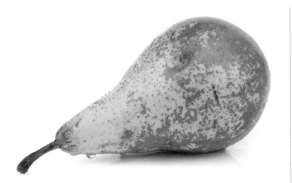

From the big picture block-in to the subtle refining of transitions, our graphite pear is now complete. These steps will be the same for any subject we might choose. When we pay close attention to contour, values, and textures, they enable us to achieve a rendering of our subjects with great detail and a quiet presence.

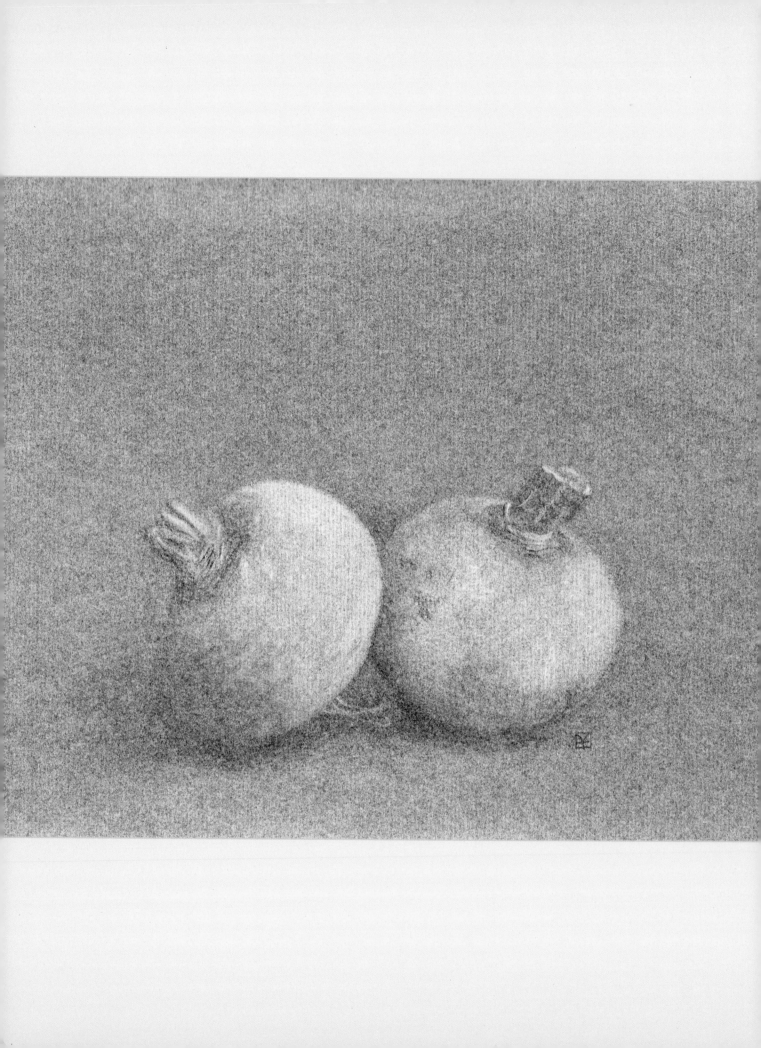

CHARCOAL

There is a certain mysterious quality to charcoal that can't be captured with any other medium. I choose it when my subject calls for dramatic contrast between dark and light and quiet subtle transitions between the two qualities. There is something quite poetic about using burnt twigs to create renderings of objects from the natural world, and to me, the best way to create this atmosphere is by using charcoal in a reductive manner.

Opposite: Turnips, charcoal

Charcoal Drawing

Reductive charcoal drawings begin with a dark background of powdered charcoal smoothed onto the paper and then immediately using a kneaded eraser to reveal the areas of light in your subject. The rest of the drawing process becomes a dance between revealing the lights and enhancing the darks, capturing textural qualities and playing up the subtle qualities of lost and found edges. Yes, charcoal can be a messy medium when compared to graphite, ink, or watercolor, but the process is uniquely satisfying as we reveal the luminous play of light on a subject that is surrounded by darkness.

As we learn to orchestrate the dance between dark and light, it will not only help to create more atmospheric charcoal drawings, but will also allow us to use the same perception of contrast for any other medium we choose to work in. Welcome to reductive charcoal drawing. It's all about the light.

Tools and Materials

Charcoal sticks: Just like graphite, charcoal comes in varying degrees of hardness, but uses a different labeling system: Hard (H), medium (HB), soft (B), and extra soft. The harder the charcoal drawing formula is, the lighter the tone will be, and the softer the formula is, the blacker the tone. For our lesson, I will use charcoal sticks by Nitram. I highly recommend these sticks, as they are artist grade, easily sharpen to a very fine point, and have a wide value range from hard to extra soft that allow me to achieve the subtlest of transitions between dark and light. You can also use vine or willow charcoal, which is readily available. If you can find vine charcoal in hard, medium, soft, and extra soft and willow charcoal (which only comes in one grade of hardness), that would be ideal. Otherwise, stick to vine charcoal, which will give you the widest array of values with good blendability.

Charcoal also comes compressed in pencil form and in small sticks of compressed charcoal. I avoid both as I find them difficult to blend and they tend to be very black without the possibility of lighter values.

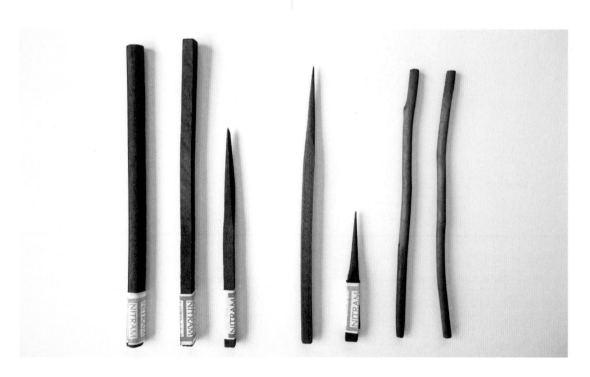

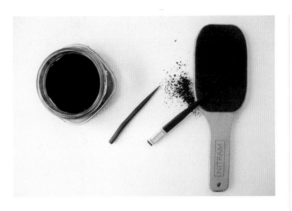

Sharpening block: I use a sharpening block made by Nitram, which is convenient and very effective. You can also use a 220 grit sandpaper block that can be found at any hardware store.

Charcoal sticks need to be sharpened to a very fine and tapered point. This takes some practice, but it will make a big difference in your ability to render properly. To sharpen a stick of charcoal, position it flat against the surface of the sandpaper, being careful not to press too hard (it can easily break). Gently sharpen the stick, moving it across the sandpaper in a circular or back-and-forth motion. Be sure to rotate the charcoal as you progress to give even treatment to all sides. It is a slow process, but I find it meditative and use the time to relax and enjoy the process of preparing my tools. You want your charcoal stick to be refined to a needle-fine point and a long taper, as seen in the photo.

Be sure to save your charcoal dust. I sharpen over a clean piece of printer paper, then transfer it to a small glass jar. I reserve my extra-soft charcoal dust in a special container, specifically for reductive drawings, and the rest I combine together in a separate jar.

Erasers for charcoal: Without a doubt, the kneaded eraser (A) is the most helpful tool for reductive charcoal drawings. I have one set aside to use only for charcoal, and I replace it when it becomes so black that I cannot knead it to a lighter gray any longer. I also use a stick eraser with a very fine point, such as the Tombow Mono Zero.

For reductive charcoal techniques, I also recommend a dry-cleaning eraser pad (B). These are small bags filled with eraser particles that you sprinkle over the drawing and then gently massage with the eraser bag. This helps to achieve a beautiful surface of charcoal to begin the drawing process. Dry-cleaning eraser pads can be found at art supply stores and online. I store mine in a small box to keep it clean when not in use.

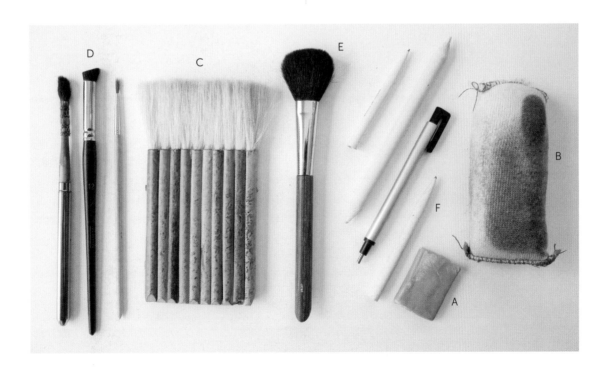

Blending tools and white chalk: We need a variety of blending tools for charcoal work. My favorite is a Japanese hake brush (C), about 5 inches (13 cm) wide. You can find these online or in art supply stores where they sell brushes for Sumi brush painting. The brush is very soft and can be used with a delicate touch for blending large areas all at once. It also is very helpful for gently removing charcoal dust from the paper.

I have a variety of old watercolor brushes (D) in varying sizes that I reserve just for charcoal blending. It's helpful to have at least one very soft, pointed round brush in a size 2 for fine detail work. Brushes made specifically for blending pastels are also great, as are old cosmetic brushes (E) that have been washed and dried. What matters most is the softness. Anything too dense and stiff will remove too much charcoal and will make your work more difficult.

Blending stumps and tortillons (F) are also important to have on hand. I keep a special container of them just for charcoal work, so that I do not inadvertently use them on the more delicate tones of a graphite drawing. Don't discard them when they become heavily saturated with charcoal dust. These become treasured tools for creating soft lines and tones in drawings.

Finally, I keep a white chalk pencil, well-sharpened, in my charcoal tool box. I only rely on it for very small details in the highlighted areas, but it does make a difference, when needed.

Paper: There are many options for charcoal paper, and not all of them are meant specifically for charcoal. If you purchase a charcoal paper, I recommend the Strathmore 500 Charcoal paper (H). It is 100% cotton, has a beautiful laid finish, and it stands up to heavy applications of charcoal, erasing, and blending techniques.

One of my favorite papers for charcoal is the Arches Sketch paper (Arches Esquisse) (I). This paper has a soft, laid texture and results in a beautiful corduroy-like finish. For a finer, smoother texture, I prefer either Stonehenge paper (J) or a hot-press watercolor paper such as Arches or Fabriano Artistico (K). The texture of our paper choice greatly affects the outcome of our drawing and should be chosen with your subject in mind. For crisper, finer detailed subjects (birds, flowers, glass, etc.), I will choose a smoother paper, and for more rustic subjects (such as tree bark, pottery, or bowls of fruit), I choose a more textured paper. Ultra-smooth papers or very thin papers, such as Bristol board in a plate-finish or anything under 90 lb (165 gsm), is not suitable for charcoal. The dust needs something to grab onto, and the paper needs to withstand layers of work and erasing.

Drawing board and easel: When working in charcoal, I always use an easel. The main reason for this is that it gives the dust the benefit of gravity, so that it can fall off the paper as you work. If you have a standing easel, tilt it so that it leans a bit forward; the dust will fall away even easier. I mostly use a table easel, as I tend to work small.

You will need a simple drawing board to give your paper a firm substrate. I use blue painter's tape to secure all four sides of my paper to a piece of hardboard. You can even use a piece of stiff cardboard. You can then secure it onto the table easel and have a sturdy surface to work on. This also keeps you from accidentally leaning your forearm onto the paper, which can result in unwanted smudges.

Fixative: Charcoal drawings can easily smudge if not sealed with a fixative. I recommend Krylon Workable Fixatif Spray. Be sure to use outside or in a well-ventilated area. A workable fixative is best because you can spray as you go. It protects your work from unnecessary smudging, but the surface is still able to be altered.

Reductive Charcoal Drawing and Preparing the Paper

Before we begin our charcoal drawing, it's important to prepare our paper properly. Then, we will take our project step by step as we create a luminous and poetic reductive charcoal drawing.

REDUCTIVE CHARCOAL DRAWING

In reductive charcoal drawing, the eraser becomes a primary tool. Instead of building up line, tone, and shadow on white paper, we'll begin with a darkened ground and use the eraser to draw in the light. There are many ways to go about a charcoal drawing, even following the same series of steps that helped us create the graphite pear on page 22. To me, however, the language of charcoal is more poetically spoken when we use it to reveal the light from the smoky foundation of charcoal already on the page.

As we begin to erase the primary shapes of light that we see in our subject, something magical happens—the highlights and illuminated areas of the subject emerge as the focal point of the drawing, creating an interplay between light and dark. Think about the dramatic light of black-and-white photos or of the chiaroscuro paintings of the Old Masters. It is a stunning form of contrast, but also lends a mysterious quality. This technique can create a subtle sense of atmosphere for even the humblest of subjects.

For this lesson, we'll create a reductive charcoal drawing of a turnip, the most modest of vegetables. Our turnip will be anything but ordinary. Let's get started!

PREPARING THE PAPER

Before beginning a reductive charcoal, you need to properly prepare the paper. Begin by taping a 9 × 12 inch (23 × 30 cm) piece of charcoal paper to your drawing board. For this lesson, I chose Arches Sketch paper for its subtle laid texture and velvety finish.

If you have not yet sharpened your extra-soft charcoal sticks, now is a good time so that you can create some charcoal dust.

Using a small spoon, scoop up some of the charcoal dust and begin to gently sprinkle it evenly across the paper. Use the reference image as a guide.

Now, take a clean paper tissue and begin to smooth the dust over the paper in a serpentine motion. Start at one end and move across the paper vertically and then begin again and move across the paper diagonally. Be very gentle, careful not to embed the charcoal into the paper. Let it simply skim over the surface. Take your board outside and blow the dust off (be careful not to spit on the paper) or hold it over the sink or trash bin. You want to excess dust to fall away.

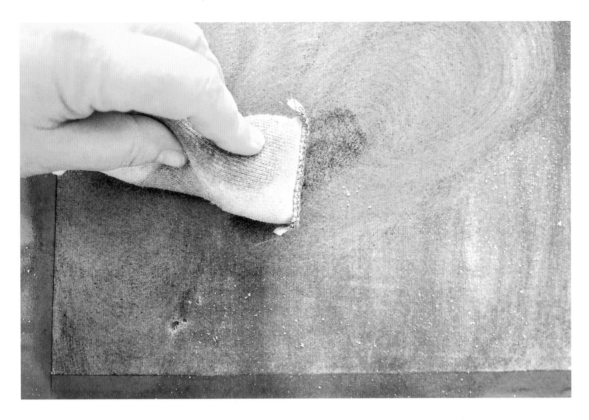

Next, using your dry-clean eraser pad, hold it over the paper and squeeze it gently to allow some of the eraser dust to sprinkle on the paper, as evenly as possible. Notice the amount used in the reference image.

Gently smooth the dry-clean eraser pad over the surface of the paper; don't exert too much pressure as you only want to smooth it, not remove the nice dark background you have achieved.

Blow off the remaining eraser particles and dust. Your paper is now ready for drawing.

Charcoal Project: Turnips

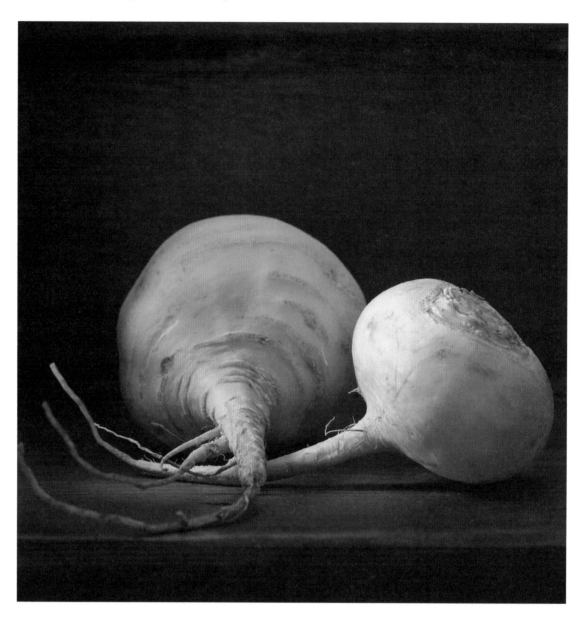

Before beginning to draw, I'd like to suggest that you make a few pencil sketches of the turnip reference photo. First, a blind contour drawing, then a gestural sketch. In the gestural sketch, really focus on laying in the big shadow shapes and leaving the highlights as pure white paper. These quick exercises will help you to see the subject more clearly and will greatly inform your approach when you begin the project.

BIG PICTURE BLOCK-IN

Using your sharpened stick eraser, sketch the basic shapes of the turnips. Be sure to notice where the line completely disappears into shadow and make only the faintest line in that area. Indicate the main shapes of the two turnips, also the roots and the way they overlap one another. Do not worry too much if your lines are not perfect. The beauty of charcoal is the ability it gives us to constantly correct and reshape lines. Just get the main shapes down, using the example shown in the guide. If needed, you will be able to correct later.

REVEALING THE LIGHT

For this step, it's important to begin with a cleaned and pliable kneaded eraser. Take a few moments to warm it in your hand and then pull it apart and knead it so that it is clean and free of any large smudges of graphite or charcoal. Now, you can mold it into a teardrop shape and position your pointer finger at the end, as shown in the example. I find that this gives me the greatest control while drawing with the kneaded eraser. If it doesn't feel natural to you, try other ways of holding it until you feel like you have good control.

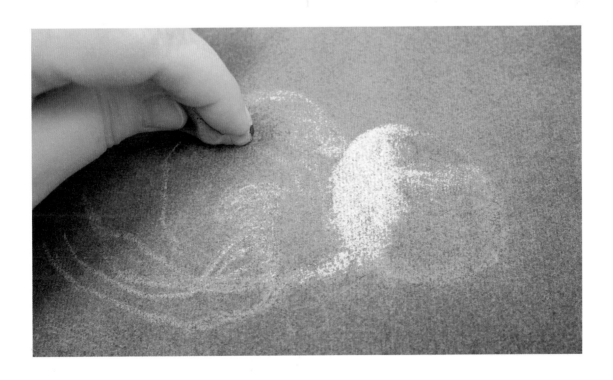

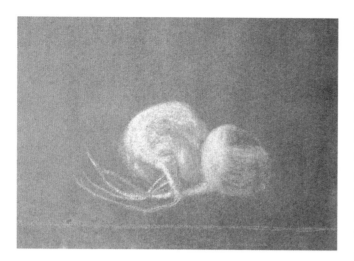

ENHANCING THE DARKS

Now that we have the highlights revealed, it's time to lay in the very darkest tones. This is where we can really refine the shape of our subject, by carefully comparing our drawing to our reference. With an extra-soft stick of well-sharpened charcoal, begin to create the darkest values that you see in the reference image. We don't need to pull the darkness all the way to the edges: having some gradual transition between dark and light in the background gives a lovely effect.

As you can see in the example, we are not adding in detail, texture, or mid-tones, just the darkest blacks that we see. This defines our subject and provides the greatest area of contrast. Pay special attention to the root area and where the two turnips touch one another. Take your time with this step. It is a great chance to make corrections to the shapes of your turnips. Our drawings do not need to be

Using your kneaded eraser, begin to lift the areas of light as you see them in the reference. I tend to use a gentle swiping or pressing motion, lifting the charcoal in layers. Notice how the areas of light are of different intensities. The softest values will be one gentle layer of lifting, while the brightest areas will require that you lift the charcoal almost all the way back to the white paper. Take your time during this step and enjoy how simply revealing the highlights creates a lovely illusion of roundness.

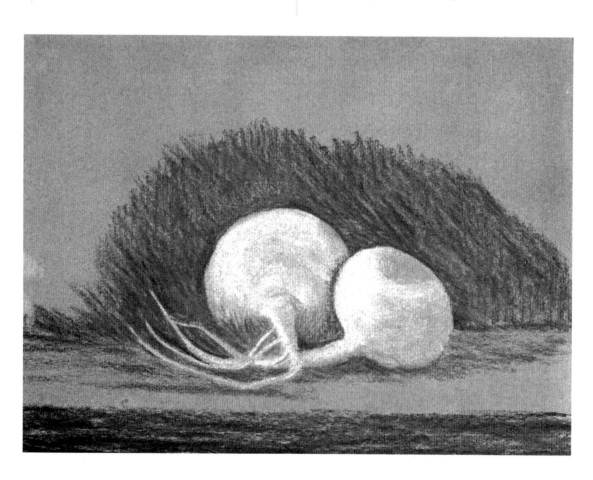

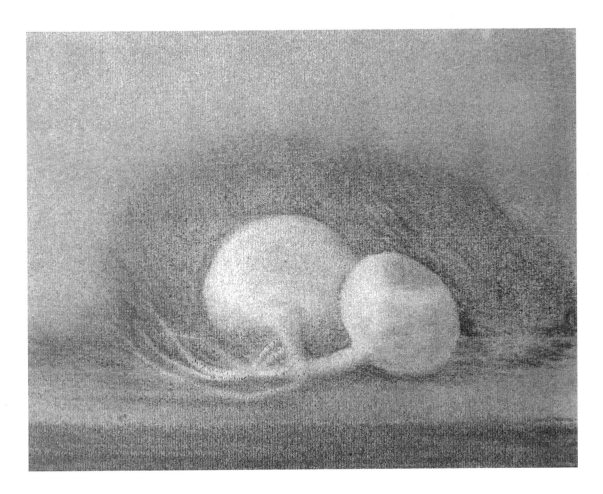

exact copies of the reference. We are trying to capture the beauty of light washed over two turnips, not a photographic replica. Also notice that there are places where my fingers lifted charcoal from the edges. We can try hard to not disturb the background, but if it happens, no worries. It can be corrected in the next step.

BRUSHING AND FIXING

This is where my students gasp when I tell them the next step. We all worry about brushing away the careful work we have done so far. Not to worry. This step brings a soft quality to the drawing and unifies the darks and lights into subtle contrast. Using your softest brush (I use a sheep's hair hake) and the most delicate touch, gently sweep the bristles across, barely skimming the surface of the paper. Move your brush in one direction only. I almost always start at the top, moving from left to right. You will see the image blend to a more subtle version of what it was before. Now, we'll begin the dance between dark and light, but first, give your drawing a light coat of workable fixative and let it dry completely.

DANCE BETWEEN DARK AND LIGHT

In this step, we reveal the brightest highlights and add back in the darkest darks by using a charcoal that is not quite as soft as the one we used first. If you do not have a variety of charcoal sticks with different hardness grades, use a lighter pressure instead.

With a clean end of a kneaded eraser or a stick eraser, pull out the areas in brightest highlight. In brushing the drawing, we lost some of that, but we also gained the chance to focus on only the brightest highlights. In the example, you can see that this is on the upper portion of the right turnip and a bit on the roots. Use a stick eraser where you need to be very precise.

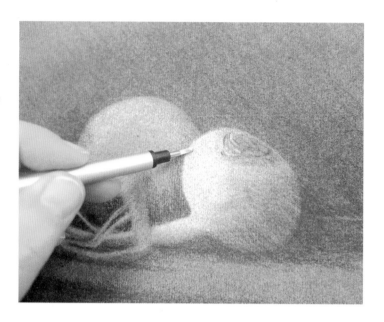

Next, we need to add the darkest darks back in. With a stick of soft charcoal (B), use directional hatching marks to build up the background that surrounds the turnips, letting it gradually blend into the lighter areas.

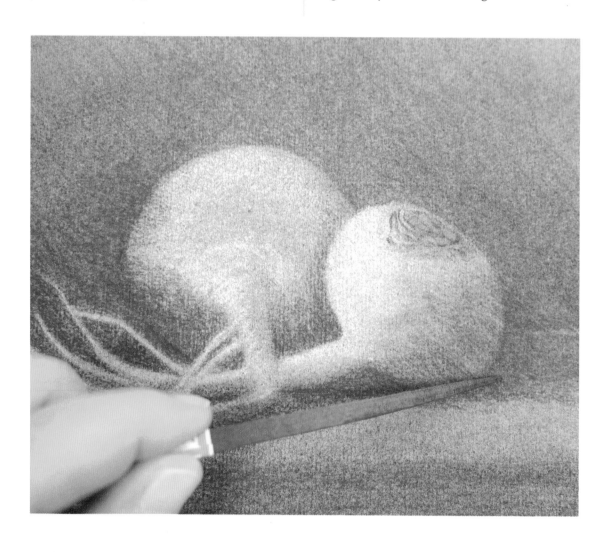

Pay close attention the edges of the turnip, making sure to keep them clean. Also, watch out for the shadows cast by the roots and between the turnips. Move around the drawing with the soft charcoal, adding back the deepest darks where necessary. This step is a bit more refined than our original blocking in of shadow, and you will notice the charcoal adheres a bit more to the surface now that we have used a light spray of workable fixative. Using a charcoal stick that is one grade harder also helps to refine the layer, as it is not as smudgy as the extra soft we started with. We can also use a small, soft brush to soften any transitions between dark and light.

We want to be sure our contrast levels are satisfactory to our own aesthetic. I prefer a softer contrast in my drawings and do not take my darks all the way to black. You may prefer a more stark contrast. Either way, this is the layer for achieving your preference. Keep moving between the eraser and the soft charcoal, until you are happy with the level of contrast between dark and light.

When this layer is complete, spray the drawing with another light layer of fixative and allow it to dry.

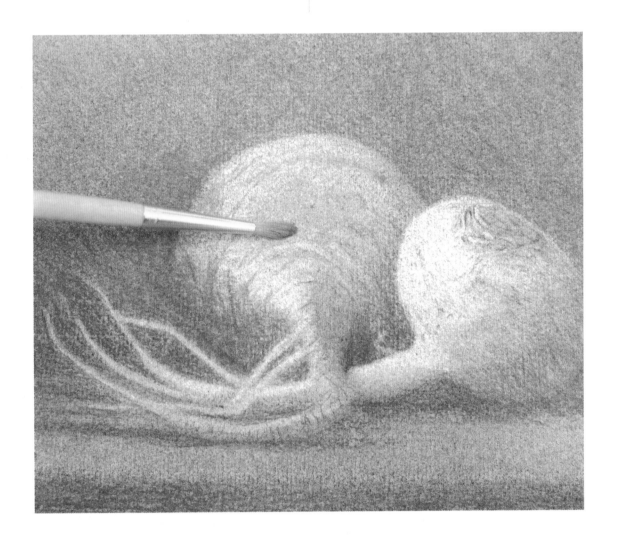

LOST AND FOUND EDGES

Take a close look at your reference image. When we are working with high-contrast, chiaroscuro lighting, we will always have lost and found edges. In some places, the outline of the subject gets lost in the shadowy darkness, and in others, the most illuminated parts of the subject are in stark, crisp contrast against the dark background. In this step, we'll crisp the found edges where there is the greatest contrast and then soften and enhance the lost edges, where the turnips

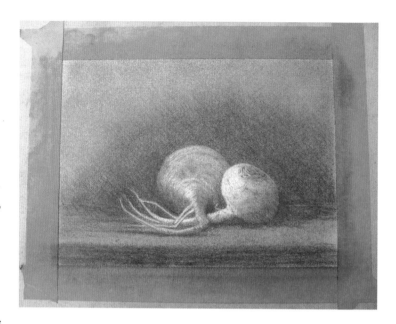

disappear into shadow. Notice how I use simple hatching to carry the darkness from the shadow area of the background into the shadow area of the turnip that almost disappears into the background. Pay attention to the roots and be sure that they are surrounded by enough darkness to make them stand out.

I chose to keep them in highlight more than in the reference image. This is a personal preference. I really wanted to highlight these roots. This step creates a sense of mystery as well as roundness of form. When finished, give your drawing another light spritz of workable fixative.

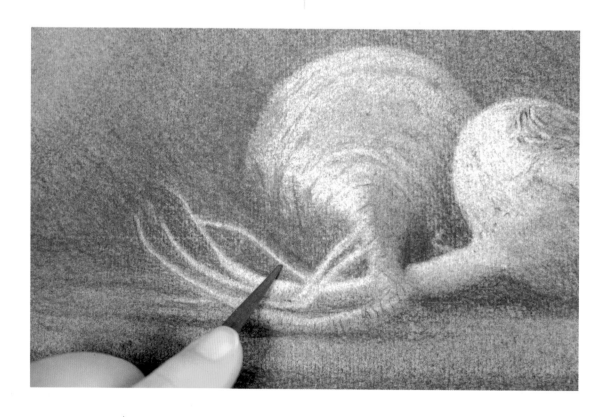

TEXTURAL MARKS IN CHARCOAL

Creating texture in a realistic charcoal drawing is no different than the way we approached it with graphite; it is all about close observation and using your tool to create the illusion of what your eyes see. We can use any variety of mark making as you move around the drawing, adding textural details where our eyes notice them.

We don't need to use a magnifying glass to realize the illusion of great detail in our drawings. We want to portray what our naked eye notices and no more. Hyperrealistic or photorealistic drawing is not what we are trying to achieve here. To me, those drawing styles lose the atmospheric quality that I am looking for—the sense of the artist's individual vision and expression. If we draw what we see and what is important to us about out subjects, that is enough.

Think of your charcoal stick as an extension of your fingertips, combing over the surface of that turnip. Make marks on the turnip, in the direction of form, that portray how your eyes and fingertips would experience that turnip. Use my example as a guide to how much texture and detail you want to add. Draw what you see, no more and no less.

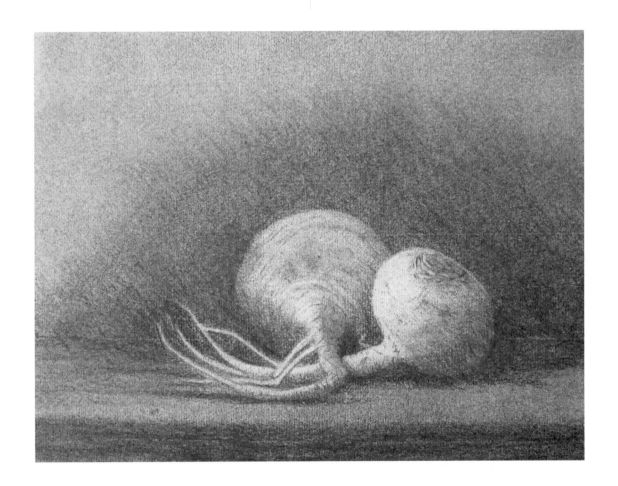

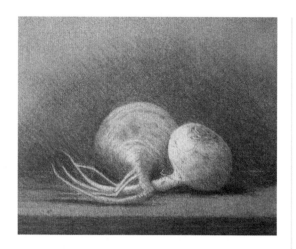

REFINING CONTRAST AND SHADOWS

Once we have arrived at this stage, it's really all about small adjustments. While our drawing might look finished at this point, it's these refinements at the end that can make our drawings extraordinary. In this step, set your drawing in a place where you compare it to your reference image. Now, take a step back and really notice where you might need to go a bit darker, a bit lighter, or make your transitions between dark and light a bit smoother. For this step, I use my hardest charcoal stick, an HB. If you are using a stick of willow charcoal, make sure it's very sharp and use the lightest touch possible. Pay attention to where you might want to adjust the background or the lost edges. Often, the adjustments at this stage are very slight.

Take special notice of the cast shadows that our subject is creating. Do you need to strengthen them? Adjust them? Notice my slight changes to the cast shadow areas, where the turnips touch the table and touch each other.

THE FINEST OF DETAILS AND THE FINISHED TURNIPS

We have arrived at a really beautiful place to be with our project. It should be looking like a finished drawing, and yet, we can use this last push to add a few small marks that will make all the difference.

Now, it's time to put your reference image away and simply look at the drawing you have created. We want this specific drawing to shine on its own, without needing to be compared to a reference image. With a sharpened stick of extra soft charcoal, add in the finest of dark lines to the areas where you need more contrast. I judge this by where my darkest darks need just a bit more punch. Often, this is in areas of fine detail or where dark areas of the subject meet cast shadows. Study the example and the image of the finished drawing to see where you might want to add these finest of dark marks. Finally, this is the stage where I might use the white charcoal pencil to enhance the brightest areas of highlight, paying attention to the top of the turnip on the right and the top edges and very tips of the roots. Again, study the example to see where I have added the smallest amount of white chalk. It is not always necessary.

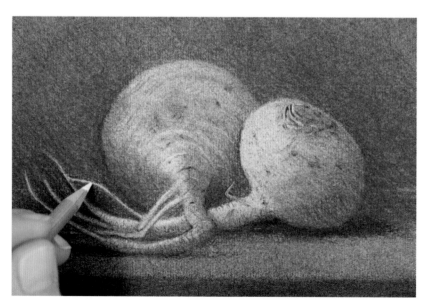

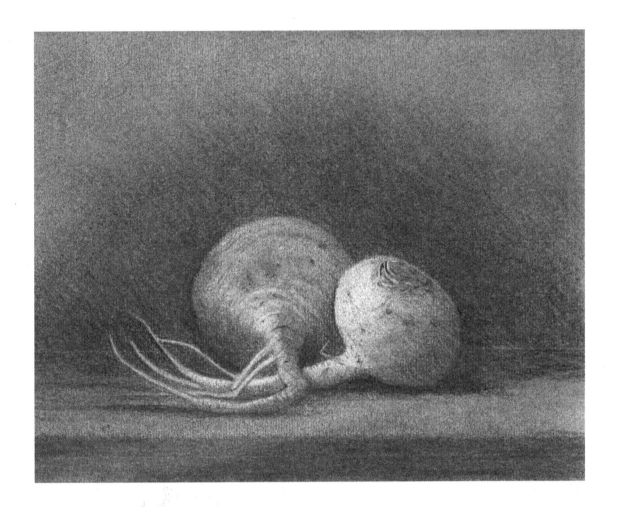

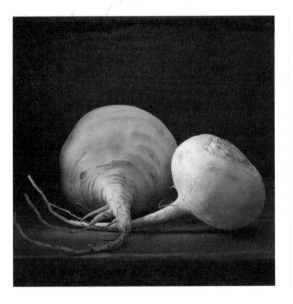

Our finished drawing of turnips captures the subtle beauty of a humble vegetable. You've learned to create a dramatically lit rendering of the subject by revealing the light and enhancing the darks. I hope you will try this technique for other simple subjects, creating something extraordinary and beautiful from the simplest of materials.

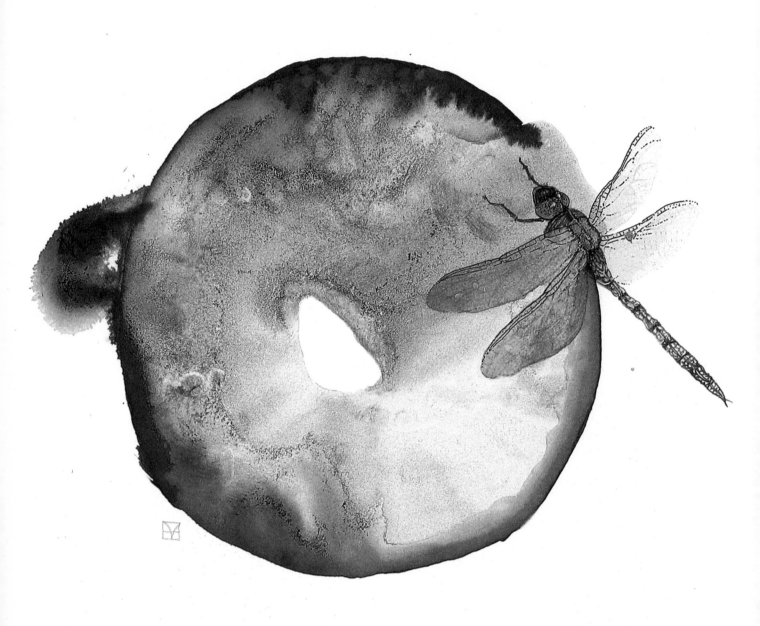

PEN AND INK

Of all the mediums I use for drawing, pen and ink is the most versatile. I can achieve a crispness of line that allows me to render in great detail, but I can also get a dreamy wash that can capture a misty atmosphere reminiscent of Chinese landscape paintings. I can use it to sharply define the outlines for a watercolor painting, or even use hatching and stippling techniques that can give every nuance of shading and form that is subtle and elegant all on its own. Pen and ink can also be combined with almost every other medium to create wonderful mixed-media art.

Opposite: Dragonfly I, pen and ink and watercolor

Pen and Ink Drawing

Before we dive into our first project with ink, we should understand the basic tools and materials needed to successfully create the effects we are hoping to achieve. Like graphite and charcoal, the supplies for pen and ink are affordable and simple, but it's good to understand the different properties of what is available to us so that we make informed purchases.

Tools and Materials

THE PEN

While there are a variety of pens available, the most basic and traditional tool is the dip pen (A)—a metal nib and holder. For our lesson, I will be using a dip pen and black ink from a bottle. While it might seem a bit inconvenient to continuously dip the nib into the ink, there is a variance of line and an ease of obtaining different values that cannot be achieved with any other method. Lines made from a dip pen are simply more nuanced in shading and form.

Metal nibs come in a vast array of styles, which can be confusing for a beginner. My best recommendation is to purchase a G Model nib (B) that was created for Manga and comic artists. The G Model is easy to find in art supply stores and online, is affordable, and has the perfect balance between stiffness and flexibility, making it easier to control than a more flexible drawing nib. You can achieve a very fine line to a very expressive, thicker line with these nibs.

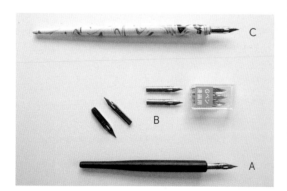

You will also need a nib holder (C) in order to use the nib, and these come from very basic to very decorative. Make sure the holder accepts the G nib. There are three kinds of nib holders: one that accepts regular nibs like the G nib, one that accepts round nibs, and a combination holder that accepts both. For the G-Model nib, you will need a regular nib holder or a combination nib holder.

PREPARING THE NIB

Metal nibs arrive with a sealant on them to prevent them from rusting. This needs to be removed before use. My preferred method is to use boiling water. Fill one small cup with freshly boiled water and another with cold water. Insert the metal nib into the nib holder and swirl only the metal nib (not the holder) in the boiling water for about five seconds. Then, swirl the metal nib in the cold water. Repeat these two steps two more times and then gently wipe the nib clean with a paper towel. The nib is now ready for use.

INKS

The type of ink you choose depends upon the effect you are looking to achieve. There are basically two kinds of inks for dip pens: waterproof and water-soluble. We will be exploring the use of both in this book.

Water-soluble ink: I choose water-soluble ink for three purposes: (1) when I want to make a drawing with ink-wash effects by using a wet watercolor brush to create shading within the drawing; (2) when I want to create many values of ink to create a more three-dimensional look; and (3) when I know I will want to use an eraser to lift ink to create even more values.

Water-soluble ink comes in many colors, and it can be great fun to experiment with different hues for your drawings. For the best results, I choose an ink that holds its line even when I apply water.

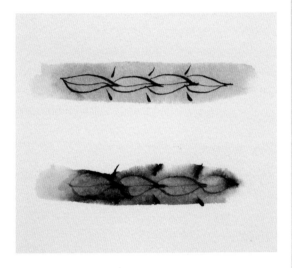

There are water-soluble inks that completely melt under a wet brush, and this will cause you to lose the line work. Most dye-based water-solvable inks fall into this category. For my purposes, I choose a Chinese carbon ink when I want to create wash effects without losing my line work. I will be using this type of ink for our projects.

Chinese carbon ink comes in bottles and is very inexpensive. It is also sometimes sold as Sumi ink or Chinese water-based ink, but be sure you are getting one that is *not* labeled *waterproof*. This ink is typically a beautiful, warm black that dilutes well to achieve the widest variety of values, straight from the pen. The technique for diluting the ink will be covered in the next chapter.

Waterproof ink: Waterproof ink is the best choice when we know we'll be using other wet mediums in our drawings, for instance a watercolor wash. These inks can still be diluted to create variations in value, but once they're completely dry, they're permanent and will not be disturbed by washes. They are also not erasable.

Waterproof inks come in a variety of colors as well, and can be very lightfast and archival. India Ink is often waterproof, but make sure the brand you are considering states it. I typically choose either acrylic inks or waterproof India ink when I need a waterproof ink or if I want a cool black versus the warmer black of carbon ink. Both are very smooth, have richly pigmented color, and can be diluted to a certain degree. We'll be using a waterproof ink for a mixed-media project later in the book. I recommend that you try a variety of inks to see which you like best.

PAPER

Once again, the quality of the paper we choose really matters when we're using it for realistic drawings. Cotton paper of artist-grade quality is the first criterion. We want it to be smooth, but not slick. When paper is smooth, the pen nib does not get caught in the texture and cause lines to become uneven. We also have to consider how the paper surface accepts the ink. Many papers cause ink to bleed and feather, which can be very frustrating. Another thing to look for is paper that is *sized*. This means that the paper was treated with gelatin, which coats the fibers and impedes the absorption of water. So, it can accept a wash if you choose to use water or water-based media with your ink drawing.

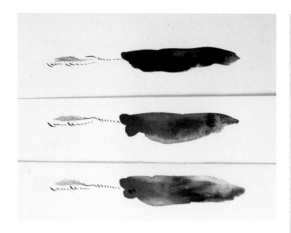

Of all the papers I have used for ink, three stand out as excellent for my purposes.

100% cotton, 2-ply or 3-ply, Bristol paper in vellum finish: Bristol paper comes in two finishes: plate and vellum. The plate finish is ultrasmooth with no texture at all. It has an almost shiny appearance that I find too slick for my ink drawings. It doesn't accept washes well, so that is also a deterrent for me. Vellum finish is still quite smooth, but has just enough texture to accept a wash beautifully. I prefer the Strathmore 500 Bristol Vellum. It is an excellent-quality paper that comes in many weights and sizes. For this project, I will be using a 2-ply in size 9 × 12 inch (23 × 30 cm).

Stonehenge: The same paper that is so wonderful for graphite and charcoal is also excellent for pen and ink. It has just enough texture, accepts light washes, and is 100% cotton.

100% cotton hot-press watercolor paper: Again, this paper has great quality, accepts washes very well, and has the perfect amount of texture for pen and ink drawings in a realistic style. My favorite for pen and ink is Arches hot press in 140 lb (255 gsm).

PENCILS AND ERASERS

Before I commit to an ink drawing, I create my initial drawing in pencil. You can use an ordinary HB pencil to create your foundational drawing, or you can try an erasable colored pencil. This is my preferred method: If I use a brighter color like red or violet, I can see my line work clearly while I'm inking. My brand of choice is Prismacolor Col-Erase. These pencils are readily available, easy to sharpen, and very easy to erase.

To erase the graphite or colored pencil lines once an ink drawing is *completely* dry, use a clean, kneaded eraser. This type of eraser is the gentlest on the paper and will not lift any of the ink. For erasing actual ink lines to create heightened values, I use a hard, white plastic eraser that I keep on hand just for pen and ink.

OTHER SUPPLIES

A drawing board can be handy. If you tape your drawing paper to a board, it provides a nice, firm backing. I typically do not use an easel when I'm working in pen and ink. I like the control of having my paper flat on the table. If you are more comfortable working on an easel, by all means try it.

I always keep paper toweling or a small cloth handy to wipe my nibs and two small glasses of water: one to clean the nib and one to use for diluting the ink. I also use a shot glass or baby food jar as a container for my ink. I find it much easier to dip my pen into the wider opening of the shot glass or jar, rather than the narrow opening of the ink bottle. I simply put the unused ink back into the bottle at the end of each drawing session.

Creating Values in Pen and Ink

If you ask a room full of pen and ink artists what their favorite method is for achieving a full-value scale in their pen or ink drawings, you will get a room full of different answers. Chances are, you come to this chapter with your own methods, too. I've tried many approaches, and I always come back to the same technique—dipping my pen in a glass of water.

This might sound odd, but it works so well. It is a technique that must be practiced a few times in your sketchbook, but then, it will become quite automatic and intuitive. It is as no-fuss a technique as I have been able to find. Here is how you do it:

1. Your setup should be as follows: A clean glass of water, your ink of choice poured full-strength into a shot glass or small jar, a flattened roll of paper toweling (or a soft cloth) for wiping your nib, a sheet of practice paper, and your dip pen.

2. Dip your nib into the ink and wipe it gently on the rim of the glass. Now, draw a ½-inch (1.3 cm) square and fill it in with cross-hatching marks in opposing diagonal directions. Then, make a row of short marks underneath. You want to see what full-strength ink looks like when drawn on the paper. Underneath your test marks, write the letter F for full strength.

3. Dip your nib into the ink again, wipe it on the edge of the glass, and then dip the nib into the clean glass of water, one time. Wipe it on the edge of the glass. Now, make some marks as you did before and label this section with the number 1, for one dip.

4. Repeat this process, each time dipping the nib into water one more time before drawing with it. This means full-strength, then dipped once, twice, three times, etc., marking each with the number of water dips. You can end with at least six dips and should have very pale gray lines.

Take a look at the example and notice the gradual shift in values from full strength to the pale value of six dips. For my purposes, I usually use one dip for my darkest areas of my drawing, four dips for medium values, and six dips for lightest. Once you begin to work to work this way, how much to dip to achieve the value you are looking for becomes an intuitive process. Practice this exercise several times to see how much you need to dip to get a dark black line versus a very light gray line.

Another way to achieve similar results is to mix the ink with varying amounts of water in several shot glasses or glass jars: a dark, a mid-gray, and a pale gray. For the dark, I use a 1:2 ink-to-water ratio; for the medium, a 1:4 ratio; and for the lightest value, a 1:6 ratio. I find that the first method of dipping the nib in water is the most convenient. Try both and use which-ever method is most convenient for you.

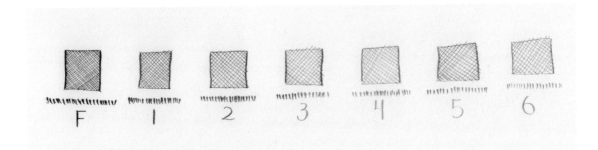

MARK MAKING WITH PEN AND INK

When working in pen and ink, our drawing techniques need to be precise. Unlike the transformable, softer lines of graphite or charcoal, ink is more decisive, permanent, and crisp. It is important to use marks that allow us to create value and contour not only gradually, but with the ability to create each at the same time. I use four types of marks in my realistic pen and ink drawings: hatching, cross-hatching, stippling, and random textural marks.

Let's look at some variances with each type of mark. I recommend that you dedicate some sketchbook pages to practicing all of them so that they become instinctual in your mark making vocabulary. When you practice them, think of a subject's different textures and forms that you can convey by using each different type of mark.

Hatching: Hatching is a series of lines made in one direction. They can be short, long, even, uneven, or even curved. When we draw in a realistic style, the subject should inform us how we use hatching, always keeping in mind direction of form.

Cross-hatching: When you make hatch marks that overlap in different directions, you're cross-hatching. Cross-hatching is very useful for suggesting both contour and shading, always keeping in mind the direction of form.

Some examples of hatching:

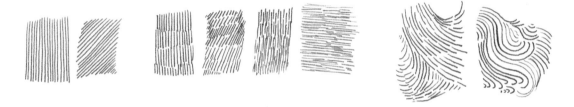

From left to right: long hatching, short hatching, uneven hatching, and curved hatching

Some examples of cross-hatching:

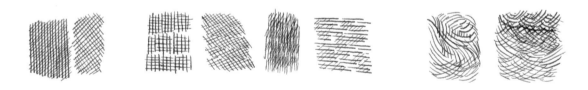

From left to right: long cross-hatching, short cross-hatching, random cross-hatching, and curved cross-hatching

Stippling: In stippling, you'll use the tip of the pen to make tiny dots. When the dots are very close together, the value created is darker. The farther apart the dots are, the lighter the value. This technique is wonderful for very precise shading techniques. It doesn't always work to convey contour or textural qualities, but it can be used to show value on textural areas of drawings.

RANDOM TEXTURAL MARKS

Just as when using graphite or charcoal, the textural marks you'll make in ink are unique to each subject and are based on very close observation of the subject's surface textures. Textural mark making is used to create the illusion of the texture we see. For example, there is no way to draw an exact replica of sea foam, but we can use random mark making to create the illusion of sea foam.

Some examples of stippling:

From left to right: using only stippling to convey value, using only stippling to convey contour, and stippling over cross-hatching to show a more refined value in a very small area

Some examples of random textural marks using pen and ink:

From left to right: feathery uneven hatching, random curved hatching, cross-hatching in four directions giving the illusion of a fabric weave, tiny hatch marks giving a stubble effect, random circular scribbles, and a basket weave effect from directional hatching

Pen and Ink Project: Pine Cone and Bough

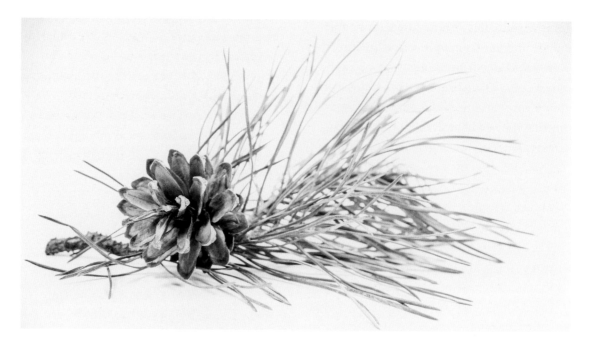

Before you commit your lines to ink, it's a good idea to create your initial drawing in graphite. Using a sharp HB pencil, create a detailed line drawing of your subject. Use the same process you would for beginning a graphite drawing: block in the picture, refine the line drawing, and erase any extra lines you do not need. I do these drawings in my sketchbook and then use a sheet of tracing paper to trace the line drawing in HB pencil. Once this step is done, I turn the tracing over and trace the same lines on the back side of the tracing paper. The reason we need to trace twice is to have our image oriented in the correct way.

Once the second tracing is complete, turn it right-side up and carefully position it on the paper you will use for the ink drawing. I use a small piece of masking tape to hold it securely in place. Without moving the paper, hold the tracing paper down with the fingers of your nondominant hand while making a rubbing with a soft graphite pencil. Be sure to not move the tracing paper at all once you begin the transfer. Continue rubbing the graphite pencil across the entire traced image. Once you are done, carefully remove the tracing paper. Your transfer is now ready for inking.

Notice the amount of detail in my pencil drawing. I was especially careful with the shapes in the pine cone and also made some

darker lines for the spot where the branch is positioned under the pine needles. For the pine needles, it isn't necessary to draw every needle, nor for them to be exact. What matters is where they initiate along the branch and the direction they take. Even drawing a few representational needles from each cluster will suffice. The needles will be inked by paying close attention to the reference image, creating the illusion of many needles overlapping one another.

When we begin to lay down the initial lines of ink, the goal is to have a layer, light in value, over the entire image. We're basically creating the same outline drawing, but in a light value of ink. Once this is complete and is totally dry, we'll erase the pencil lines of the transfer drawing.

Because we want this layer to be light and uniform, we need to mix up a small quantity of ink to make it easier as well as consistent. In a shot glass or jar, add ½ teaspoon (3 ml) of ink and 2½ teaspoons (13 ml) of clean water. Stir them together. We will use this 1:5 ink dilution for the first layer.

When making realistic drawings in pen and ink, be mindful of not creating a hard or dark outline, especially when areas of the drawing will have lost, or very light, edges. We do this by using the lighter value of ink but also by using broken lines.

Look at the reference image and notice where the pine cone has edges that are very light, or even white, in value. In drawing these in the first layer, we'll create this "light" by using broken lines, or even stippling, so that we do not have a strong outline. Look closely at the example shown to see how this might look in this particular project.

Begin to ink the transfer drawing by starting on the left side of the image if you are right-handed or the right side if you are left-handed. (This will ensure that our hands do not accidentally smudge the ink while it is still wet.) Pay close attention to your

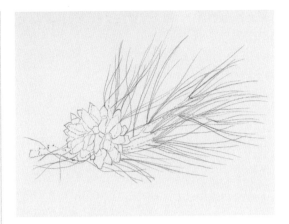

The first layer of ink and broken lines

reference image or subject while inking over the pencil lines, using broken lines whenever you come to a place that requires it. Once you're finished, allow the drawing to dry for at least one hour before using a clean kneaded eraser to gently remove all traces of the graphite transfer drawing.

PEN AND INK: FILLING IN THE FORMS

Now that we have an outline of the drawing created in the first layer of ink, we'll use directional hatching to convert the contour of each shape. For this layer, we'll focus on the pine cone and the branch. Our goal is to lay down these directional hatch marks first in a light layer and then to cross-hatch with a darker value of ink. These steps will create a drawing that shows the beginning of the illusion of roundness—this is always the goal in creating realistic drawings no matter what medium we are working in.

Pour some of your ink into a shot glass or small jar and have another glass of clean water next to it. Have some clean kitchen toweling on hand for dabbing your nib to remove excess ink. Paying close attention to the reference image, begin to fill in hatch marks in the direction of form (the natural line and contour direction of the subject) with a 1:5 ratio of ink (that is either 5 dips into the water or a pre-mixed dilution of 1 part ink to 5 parts water).

Another reason that I prefer the dipping method is because it gives me more random variations in value, which I find pleasing. If you prefer a more uniform value, use the premade dilution of 1:5.

Notice the lighter areas of the sample drawing to see how directional hatching should look. Keep it simple and light, only filling in the areas that are light. When you have completed this layer, it's time to use cross-hatching marks in a mid-value ink of 1:3 ratio (three dips or 1 part ink to 3 parts water) to fill in the darker areas. Always keep your lines moving in the direction of form.

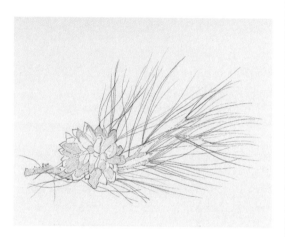

Pay special attention to the areas where the sample drawing has the darker cross-hatching. We are not putting in the darkest darks or fine details; we are simply filling in the contour of our outlined subject. When these steps are complete, allow your drawing to dry completely before moving on.

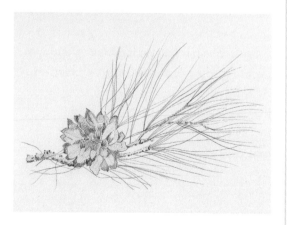

ADDING DETAIL, TEXTURE, AND CONTRAST

The drawing is now at the stage where we can address the fine details and textures and add in the areas of darkest contrast. We haven't worked on the pine needles since drawing the initial lines. Those first lines expressed the direction and flow of the needles, but not the details or values. It's not our aim to make an exact replica of each needle in the reference but, instead, to create the illusion of pine needles growing from the branch in groups.

I try to remember this good bit of advice: When drawing, we're not trying to draw pine needles, but the lines, shapes, and values of what our eyes notice about the pine needles. Let's look at how this might translate onto our drawing.

If we closely examine the reference image, we notice two things. First, the needles are randomly growing from specific areas on the branch. They grow in clusters. We want to draw them in clusters. Second, the needles overlap one another and therefore create shadows where this occurs. We can show this by using different values of ink.

As always, we begin with the lightest values. For this drawing, we did that when we drew the first lines depicting the needles. Now, we'll use a medium-value ink of either three dips or a 1:3 ink to water ratio. Paying close attention to the reference image, notice how each needle appears to have two lines defining it. Begin to define each pine needle that you have already drawn by adding another line, very fine, parallel to the line that is already there. If the needle crosses another, decide whether it is above or underneath. If it's passing underneath, stop the line where it meets the needle resting on top and begin it again just the other side. If it crosses over on top, draw the line directly on top of the needle it passes over. Here is an example of three needles with the additional lines added.

Move across the drawing and create the second line for each needle. I find it easiest to begin at the tips of the needles and carefully follow them back to where they began. When this step is complete, allow the ink to dry completely before moving on. Always allow each layer to dry, so you don't accidentally smear as you begin the next step.

Once the needles are finished, we can turn our attention to details on the pine cone and branch. Look for any defining marks in the reference image or subject that stand out and make our subject unique. One thing about the pine cone is that is has light areas where sap has dried at the tips of cone segments. I can define these areas by using stippling or cross-hatching around them, with tiny lines and dots to emphasize the light shapes. Also, on a few sections of the cone, there are lines in the center. I can add these as well. Our branch is fairly simple and we have already defined it quite a bit, but at this stage, I want to be sure I have added marks that portray all of the subtle details of every part of my subject. I make hatching or stippling marks with either a light value ink of 1:5 ratio or a mid-value ink of 1:3 ratio for these fine details, depending on the value of the detail I want to create. Take a close look at the sample drawing to see where I have added in fine details to the pine cone and branch and where I might I use hatching or stippling.

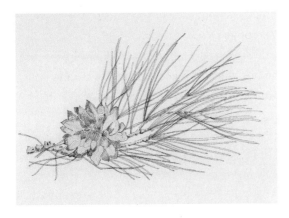

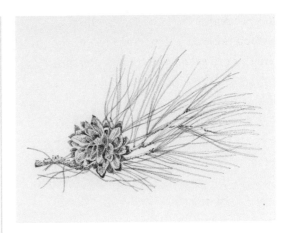

ADDING THE DARKEST DARKS

Now that the drawing is almost complete, we need to return to compare the reference image or subject to the drawing. Squint your eyes and notice where the darkest areas are on your reference image. These are details we will add in this final step of drawing.

On the pine cone, it's fairly clear that the darkest areas are where the sections meet and are in shadow in the center of cone. We also have dark areas at the tips of the outer sections of the cone. Our branch shows darker areas all along the bottom edge as well as the tiny textural spikes along all sides. Our needles show a darker value where they rest on the table, as well as where the needles overlap.

Paying close attention to the reference, add in these small areas of darkness with the tip of your pen using stippling or other types of marks and a 1:2 ratio of ink to water. I dip my nib into the full-strength ink and then once into my water glass, lightly dabbing the tip on a paper towel to remove any excess ink before I begin to draw.

Once this step is complete, allow your drawing to dry completely before moving on.

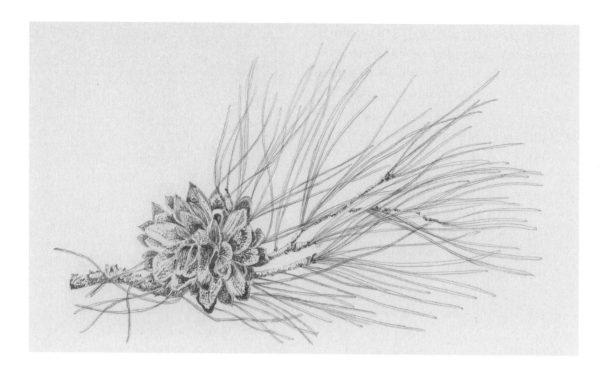

ERASING INK

One of the benefits of using Chinese carbon ink is that it can be lightly erased once it has dried. The marks cannot be erased completely, but they can be lightened with the gentle use of an eraser. This is helpful for revealing any areas of the drawing that might have a wash of light on them, or are generally lighter in value, without losing any of the details we have added.

Some white plastic erasers will erase diluted carbon ink quite a bit, while others do not work as well. I have found that using an eraser meant for ink usually has a grittier feel and works best. Make sure you use an eraser that is reserved for ink drawings only. This diminishes the chance of staining the paper with graphite or charcoal that might be left on the surface of the eraser. I find that Prismacolor's Magic Rub eraser works quite well when used with a delicate pressure.

Looking closely at the reference image, notice any area that is generally lighter in value and compare it to your drawing. You don't always need to include this step, but if we do find areas that are darker than the reference, we can use an eraser to bring some light back.

In comparing my sample drawing to the reference image, I noticed that the left side of my pine cone was not as light. Using a plastic eraser, I gently worked it back and forth until I had removed just a bit of the ink. I also used the eraser on the upper tips of the pine needles toward the top of the drawing. The change is subtle but effective.

FINAL DETAILS AND THOUGHTS ABOUT PEN AND INK

At this stage, I can consider my ink drawing complete, but as with any medium I'm using, I like to take a refined look at my work as it stands on its own. While relying on the reference throughout this process, there comes a time when the drawing must be regarded as its own representation of the subject.

Put your reference image aside and simply look at your drawing. Does it feel balanced in contrast? Are there any areas that stand out to you as needing a bit more depth or even light? Are you happy with the contrasts your marks created? Does the drawing need more stippling or hatching or any kind of intuitive marks to really give it presence? What about a cast shadow? Does your drawing need one?

For this pen and ink drawing, I did not find the very subtle cast shadow in the reference to be consequential enough to include it. I made the decision to leave it because I felt it might confuse the viewer's eye or simply make the image too busy. The focal point is the lovely pine cone and the graceful groupings of pine needles. Also, in botanical illustration, it is quite customary to leave out any cast shadows. We can prove contour and shadow within the subject itself. By not adding the cast shadow, we let the subject shine all on its own.

Looking at my own drawing, I felt I wanted to enhance some of the areas of greatest contrast—the darkest darks. Using straight, undiluted ink, I carefully adding some fine stippling marks where I felt the added contrast would be valuable. Then, I felt my drawing was complete. I could sign it and leave it to dry.

Learning to see is about taking the time to really be present with our subjects and to examine them closely along every stage of the drawing process. The few moments we spend with the most subtle details at the end of our project can make all the difference in our work.

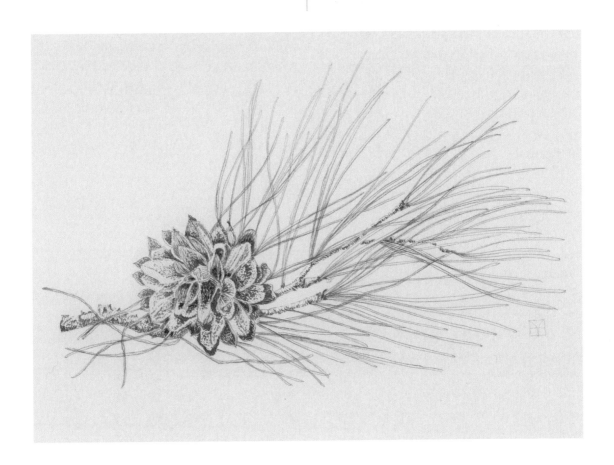

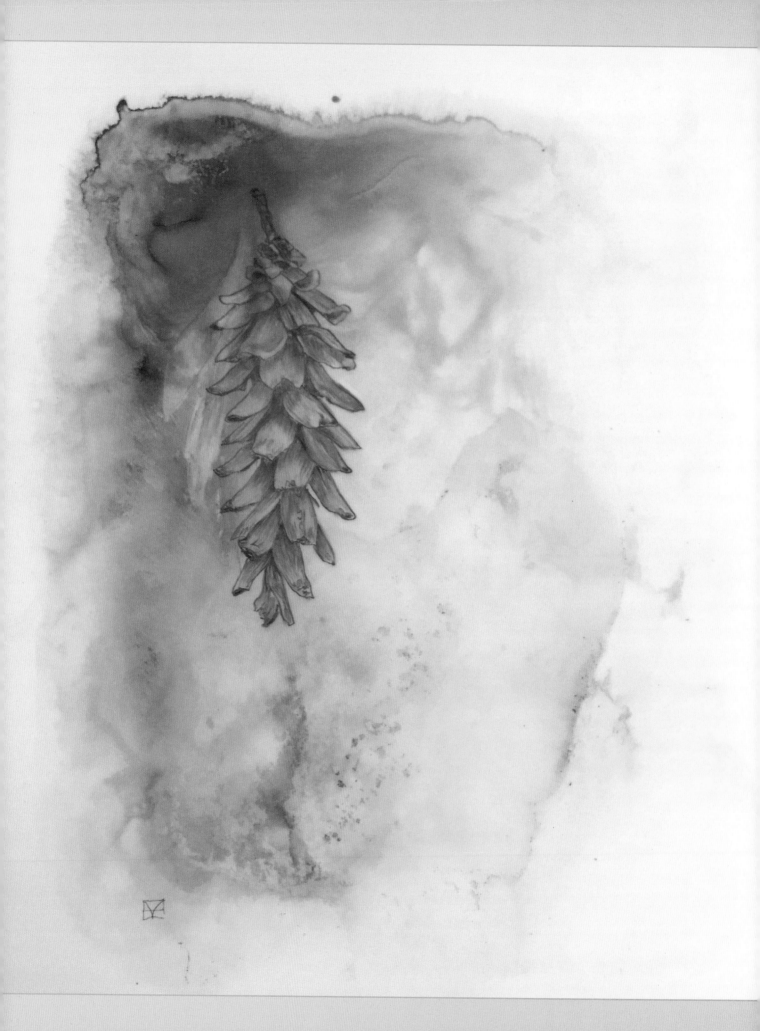

WATERCOLOR

The very first medium that I learned was watercolor, and it remains the one I go to most often. Perhaps it is the desire to be immersed in a rainbow of color, subtly enhancing my drawings when the subject calls for it. There is nothing like watercolor for adding dreamy washes of color to your drawings. You can use it as a simple background behind a pen and ink or graphite drawing, or as a precise form of drawing all its own, with a finely pointed brush that can rival the sharpest pencil.

Welcome to the beautiful and expressive medium of watercolor.

Opposite: Pine, graphite on watercolor

Drawing in Watercolor

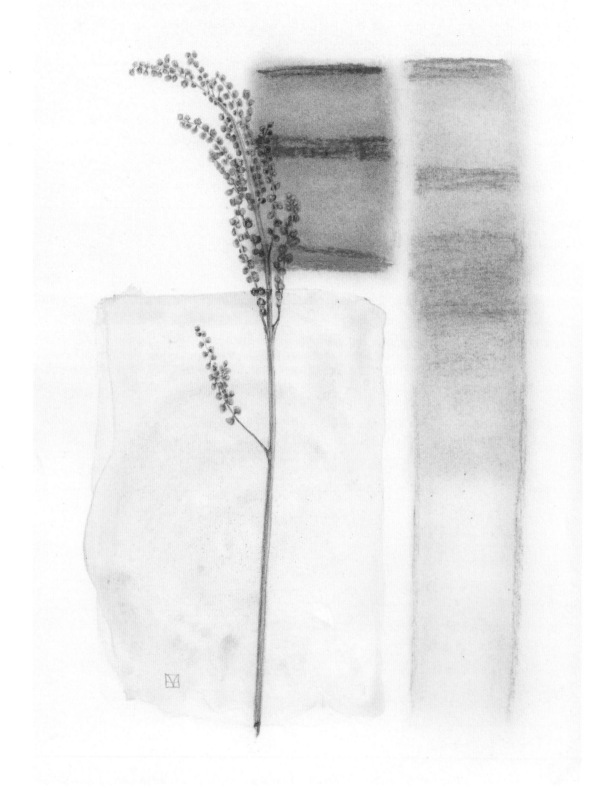

Sonata 1, mixed media

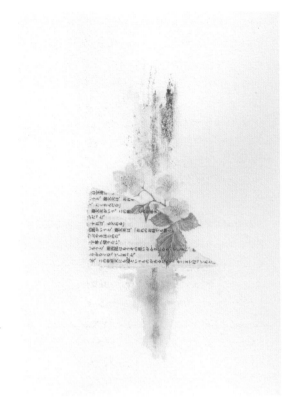

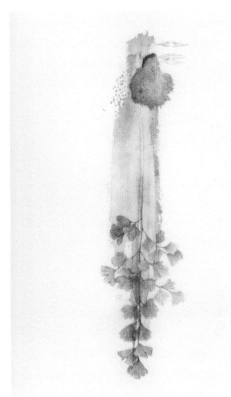

Sonata 2, mixed media

Sonata 3, mixed media

You might be surprised to find watercolor described as a drawing medium because you've thought of watercolor as a looser, more expressive medium than graphite, charcoal, and ink. But think of botanical illustrators who use watercolor to create their refined and realistic portrayals of plants. They're painting and they're also drawing with watercolors. We can use this versatile medium to enhance our realistic drawings in graphite and ink, lending dreamy background washes of color that bring a refreshing expressiveness to our subjects. This chapter is not an in-depth look at watercolor techniques for realism; rather, it offers several useful techniques to help you bring some color to your realistic mixed-media drawings.

To prepare for adding color to our portfolio of mediums, we'll need to discover the tools and materials that are essential for watercolors.

Tools and Materials

I want to emphasize the importance of quality over quantity in tools, no matter what medium we choose. Watercolor is a vast medium and there are thousands of possibilities that confront you when you purchase supplies. For our purposes, we will keep it simple: the best quality paints you can afford in a handful of colors that you truly love, artist-grade paper that allows for wet washes while holding up to drawing techniques for both graphite and ink, and one or two excellent brushes that will serve you well.

WATERCOLOR PAINTS

If you already have a selection of watercolor paints, whatever you have will work just fine. If you are looking to purchase some, here are some things to consider:

• **Pans versus tubes:** Both work very well, but there are advantages to each of them.

Choose whichever suits you better. Pans are very convenient, usually less expensive, and are great for on-the-go sketching. However, it is more difficult to create large mixtures of wash colors from a tiny pan. Tubes can be a bit more of an investment, but they last a very long time and can be squeezed into empty watercolor pans to create your own travel set. They are also much easier to use for mixing larger amounts of paint for washes.

No matter which paints you choose, make sure they are artist grade and not student grade. Artist-grade paints have a much higher percentage of pure pigment and very little binder. Student-grade paints are often dye-based and much weaker in strength since they have a larger percentage of binder. This decreases their costs, but it also decreases their brilliance and intensity. The special properties of pure pigments can make a difference in the look of your washes.

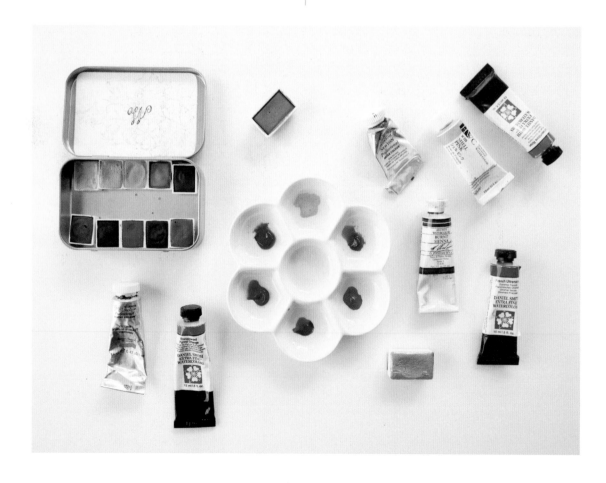

- **Color selection:** For the projects in this book, we'll choose colors that appeal to us, as well as basic colors such as the *split primaries*, which can be mixed to create the entire spectrum of the color wheel. A six-color split primary palette is all you really need to create almost any color you can dream of. It consists of both a warm and cool version of the three primaries: red, yellow, and blue. Artist-grade watercolors are identified with both a common name, such as French Ultramarine, and also a pigment number, such as PB29. While different paint manufacturers may have creative names for their colors, the pigment numbers are a sure bet that you getting the right pigment. I always shop by pigment number. Here is a list of pigments that work well for a split primary palette, identified by both their common name and pigment number.

 - Warm Blue: French Ultramarine (PB29)
 - Cool Blue: Phthalocyanine Blue Green Shade (PB15:3)
 - Cool Yellow: Hansa Yellow Light (PY3)
 - Warm Yellow: Indian Yellow (PY108) or Hansa Yellow Deep (PY65)
 - Warm Red: Transparent Pyrrol Orange (PO71) or Pyrrol Scarlet (PR255)
 - Cool Red: Quinacridone Rose (PV19) or Permanent Rose (PV19) *PV19 can also be more violet or magenta in hue, so look for either of the names above to be sure you are getting the correct version.*

While a split primary palette is ideal, the projects we will cover in this book can be created with any basic watercolor set. If you want to purchase a set, buy one with twelve basic pigments in the best quality possible.

I would also like to mention handcrafted gemstone and mineral paints, which can be wonderful complements as a background for graphite and ink work. These paints are unique in their coloration and textural qualities and are quite beautiful in simple background washes. There are many artisans creating these handcrafted watercolors. I've included a list of my favorites in the Resources section at the end of this book.

WATERCOLOR PAPER

Here again, we enter a realm of myriad possibilities. I recommend keeping it simple and using a 100% cotton mixed-media paper or hot-pressed, 100% cotton watercolor paper in 140 lb (255 gsm) weight. These papers tend to be smooth enough for ink, but with a bit of tooth for the adhesion of graphite. It's important to use a paper that has been sized, so that watercolor flows well on them, and both of the papers mentioned above have this quality. There are some cold-pressed papers that are smooth enough for realistic drawing techniques, so if you already have some, check the surface texture. If the texture is visually noticeable, it's probably too rough for our purposes.

Note: When using these mixed-media techniques, you will want to tape your paper on all sides to a rigid drawing board to keep it from curling at the edges.

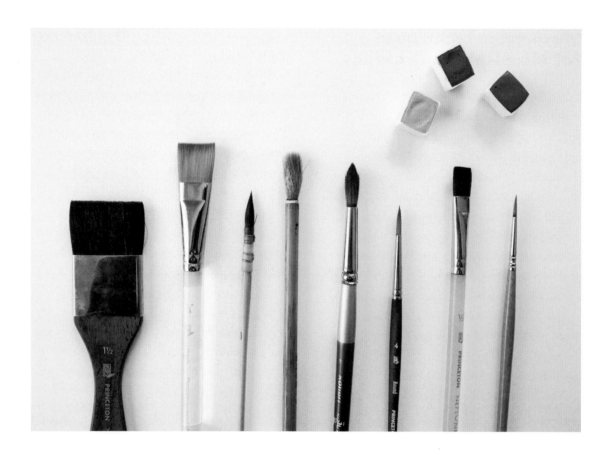

WATERCOLOR BRUSHES

You really need only two brushes to cover the techniques we'll be using for our mixed-media projects. Again, quality matters. I recommend a size 8 pointed round brush and a size 4 pointed round brush. You might also want to explore flat wash brushes in varying sizes and even Chinese brushes for their own unique qualities. Here is what to look for in a water-color brush:

- **Ability to hold water and paint:** A watercolor brush needs to be made of absorbent material, whether it is natural, like sable or squirrel, or synthetic. Less expensive brushes tend not to hold much water. This becomes frustrating when you can't finish a stroke without needing to stop and reload your brush. Most sable or squirrel brushes hold plenty of paint. Synthetic brushes that are sold as "synthetic squirrel" or "synthetic sable" are usually fine. Two excellent brands of synthetics are Princeton Neptune and Kolibri Squi-Line.

- **Springiness:** A watercolor brush's ability to snap back to a fine point after each stroke is so important. You don't want it to be too stiff or too floppy. Again, sable is top notch for springiness, but the synthetics perform very well also. For finer details, a synthetic brush on the stiffer side can give you more control. Escoda Perla White Toray are my favorite synthetic brushes for pointed rounds under a size 5.

OTHER SUPPLIES

- Two jars of clean water: one for rinsing your brush and the other for clean water
- A roll of paper toweling or a soft cloth for wiping brushes
- A drawing board and paper tape to secure your watercolor paper

Watercolor Techniques for Mixed-Media Drawings

There are four basic watercolor techniques—the wash, the charge, pulling and softening, and layering—that we will explore for mixed-media applications in our drawings. Each of these has its own specific charm and use, but they can all be used together to create effects to enhance your mixed-media projects. I suggest practicing them each on their own to get a feel for how they might be useful to you in your own work.

As you work through these techniques, notice how they build on one another and work together. You might notice how the techniques shown get gradually more realistic. Each has a value on its own, and yet all must be combined when we wish to achieve the most realistic results in mixed-media drawings.

THE WASH

A watercolor wash background is a perfect complement to realistic drawings in graphite and ink. A wash can also be used as a toned background for charcoal drawings. Adding some glowing color to our drawings is always fun. We want to make sure the color does not draw attention away from our subjects but enhances them. Subtlety is key. A sheer and subtle watercolor wash is something that we need to practice a few times to get the best results.

Often, in first beginning to use washes, we end up with streaking or overlapping lines. Here are some helpful techniques to practice for the best results.

There are many types of washes used in watercolor, the main two being the smooth wash and the graduated wash. For mixed-media work, I have another that I like to call the dreamy wash.

The Smooth Wash

When a smooth, transparent wash is your objective, the most helpful tip is to allow gravity to assist you. This is easily done by angling the drawing on an easel or by resting your drawing board (with the drawing attached) on a flattened roll of paper toweling.

We'll want to mix our paint with plenty of water to create the right value of pigment for the desired effect. I usually do this in a small ramekin, teacup, or bowl. Make sure to mix enough paint so that you do not run out. Using a larger pointed round brush or a flat brush, dip it into the paint wash until the brush is saturated. Beginning at the top left-hand corner, run the brush across the paper so that you have a bead of paint at the lower edge of the wash. This is where gravity helps us.

After the first pass, dip your brush in the diluted paint once more and begin again at the left-hand side, picking up the bead and moving it across the paper. The bead of paint ensures that the wash remains fluid as you carry it across and down the paper. Take care never to go over the same line of paint twice.

Simply begin again at the left, picking up the bead and carrying it across, working your way down through the area where you want the wash applied. After the final row of paint, dry your brush and use the tip to wick up any paint that has beaded along the bottom edge. Leave your paper at an angle until the wash has dried.

The Graduated Wash

This is created in the same way as the smooth wash, except that you add clear water to your brush, instead of more paint, before each new pull across the paper. By doing this you achieve a wash that graduates from dark to light. You can also use the same technique to make a variegated wash, by simply changing colors as you work your way down the paper.

The Dreamy Wash

This is my favorite wash for mixed-media work, when I want a soft background to enhance my graphite or ink drawing. I usually stick to one or two colors, to keep the wash subtle and not draw attention away from the drawing itself. For this wash, I leave my paper flat on the table, usually taped to a drawing board.

Using clean water and a large pointed round brush or a flat brush, I wet the paper in the area where I want the wash of color. Then, using my pointed round brush, I drop one or two colors of watercolor paint on the inside area of the water glaze, leaving about 2 inches (5 cm) of clean water glaze all around.

I allow the paints to move freely across the wet surface and mix and mingle with one another. I then tilt my paper in each direction, which helps the paint to move across my clear water glaze, creating soft edges and subtle mixtures between the two colors. If I want blooms and texture in my dreamy wash, I might splash some water drops onto the paint or even add a sprinkle of salt. Once you are happy with the wash, leave it flat to dry thoroughly.

THE CHARGE

The charge is a perfect technique for adding interesting color to our mixed-media drawings. It's especially useful for drawings where we wish to add a pop of color. The basic idea is that the colors are applied pure, without mixing the pigments: You create interesting effects by charging one pure color into another, letting the pigments work their own magic.

We need to be mindful of the colors we choose so that they create the effect we are looking for. I typically select between two and five colors, narrowing my choices by considering my subject. Am I drawing a botanical subject that I wish to have a sense of realism? If so, I select colors that would be related to my subject in nature. If I want to be bold and expressive, I will choose colors that reflect this decision. The same goes for more muted palettes or groups of colors that might suggest a specific feeling or atmosphere. My best advice is to keep things simple with no more than five colors. This gives the work a sense of harmony.

The technique itself is quite simple. In these examples, I have drawn a simple leaf with waterproof brown ink. In the first example, I chose colors that would give a more stylized, boldly expressive effect. In the second example, I chose colors for a more natural, yet still stylized effect.

This technique is worked *wet-on-dry*, which means applying wet paint to dry paper. Begin with one color and then, working quickly so the paint remains wet, dip the brush into another color and being applying it to the edge of the first color. Continue this way across the subject, letting the different pigments charge into one another, mixing and mingling on the paper. Practice this with many combinations before you begin working on the actual drawing. It's often surprising and quite pleasing how different pigments react to one another, creating effects that are spontaneous and fresh.

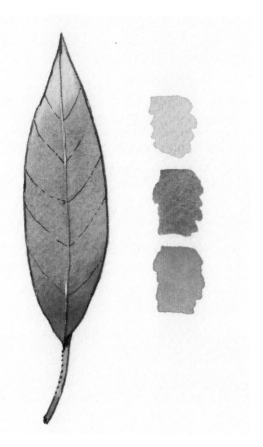 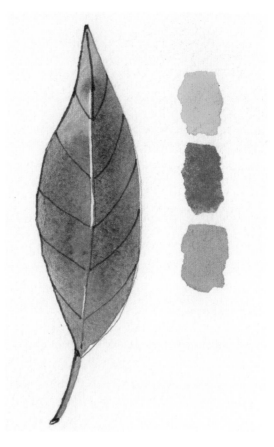

PULL AND SOFTEN

This technique creates more controlled and subtle effects and is perfect for when we want to add shading with watercolor to our mixed-media drawings. This technique is worked wet-on-dry.

In the example shown, I have drawn the same simple leaf, but instead of charging the color in, I created a more realistic effect by adding washes of color in strategic places and then pulling and softening the edges to create form and shading.

To create the illusion of the leaf being curved up at the edges, I began with a darker wash of green on dry paper toward the center vein. Then, immediately, I used a clean, damp brush to pull the color out toward the edges, softening it to a lighter value toward the outer edge. I then repeated it for the other side of the leaf. Use this technique whenever you wish for a bit more realistic effect and subtle shading.

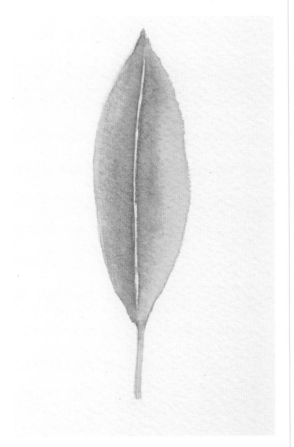

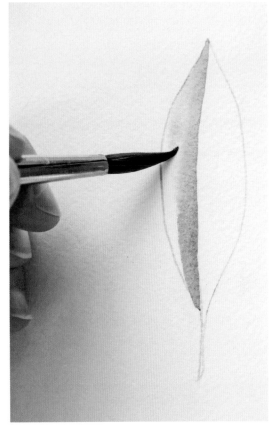

LAYERING

Layering watercolor washes from light to dark gives the most realistic effect when creating mixed-media drawings. By beginning with subtle washes and gradually building up the values and contrast, we can achieve a realistic-looking subject with texture and detail. Here is an example of layering water-color on a graphite drawing of the same simple leaf.

The Lightest Value Wash:
Mix up a light wash of natural green. (Ultramarine blue and quinacridone gold, or any warm golden yellow, are choices that will create a glowing, warm green.) Add lots of water to create a paler wash for the lightest value. Apply this layer to the entire leaf.

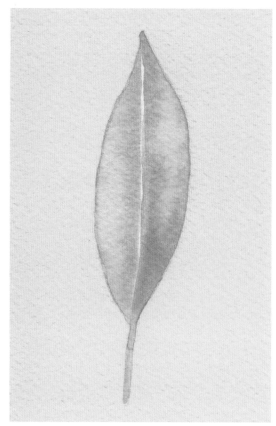

The Mid-Tone Value Wash:
In this layer, create a mid-value green by adding more of each pigment, plus a very tiny bit of red paint to deepen it. Begin with a water glaze, clean water applied evenly to one half of the leaf, and then drop in the green paint toward the edges, leaving the center area of that one side pale. The water glaze helps to pull the paint across the surface in a soft manner with no hard edges. Apply the same technique to the other side of the leaf, leaving a very narrow space where the center vein would be, free of any paint. This layer must dry before you move on.

Adding the Deepest Values:
Create an even deeper mix of green using more of the blue, gold, and red. Repeat the same process as with the mid-value layer, using a water glaze and then dropping in the deepest darks where you see them. If you do get dark paint seeping in where you don't want it, use a clean damp brush to wipe and lift the excess paint away. Let this layer dry completely.

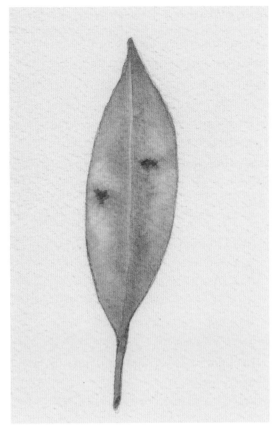

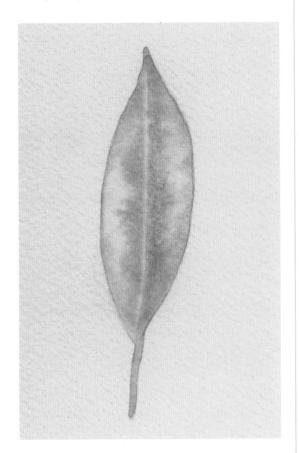

A Unifying Layer and Fine Details:
For this final layer, mix a pale and glowing warm green in a very transparent wash. Coat the entire surface of the leaf, being mindful of the edges. This will unify all the layers and give a glowing finish to your leaf. While it is still damp, drop in darker tones where you might need them, including any small blemishes or soft marks. For the leaf, you can use a deep brown, dropped in when the surface is almost dry, but wet enough so that the paint blends in softly. You may also wish to add fine details once this layer dries, using the wet-on-dry techniques covered in a later chapter.

Practice all of these techniques until you are comfortable with them on their own and by combining them in various ways. Then, we will create our first mixed-media drawing project.

Graphite and Watercolor Project: Beech Leaves and Nuts

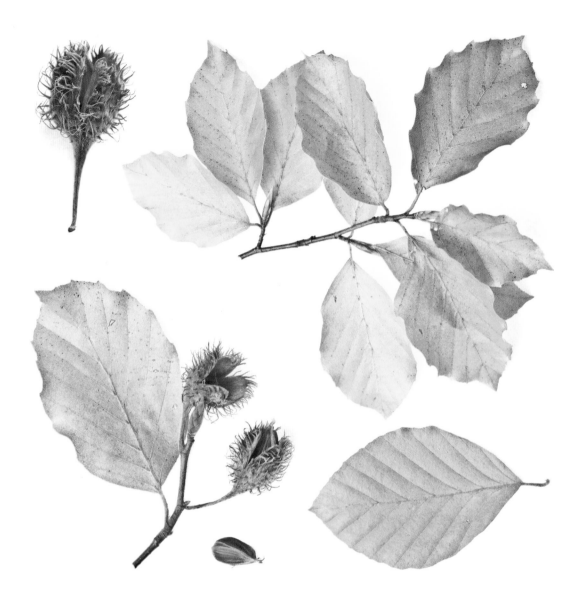

For our first mixed-media, realistic drawing project, we'll create a drawing on a watercolor wash background. The reference image provides several groupings of beech leaves and nuts for you to select from. The composition and colors can be anything you choose. Make it your own, while following along with the steps needed to create this unique project.

TOOLS AND MATERIALS

- Two or three watercolor paints in the colors of your choice: I used Wildthorne watercolors in Viridian (a medium, cool green), French Ochre Leger (yellow ochre), and Sun Gold Mica (a metallic gold paint). These paints are handcrafted from minerals and gemstones, which are perfect for these simple background washes. They create beautiful and subtle colorations and textures. I chose these colors because I wanted the dreamy effect of sunlight streaming through leaves in the forest. Any watercolor paints will work beautifully for this project. Select two or three that appeal to you.
- Watercolor brush, size 8 (or larger) pointed round brush or a flat brush at least ¾ inch (2 cm) wide

- Hot pressed watercolor paper, 9 × 12 inch (23 × 30 cm), either in a block or taped to a small drawing board
- Graphite pencils in various hardness levels
- Erasers

STEP ONE: CREATING A DREAMY BACKGROUND WASH

Following the steps we learned in the previous section, create a subtle background wash in the center section of your watercolor paper. Avoid taking the wash all the way to the edges so your paper does not buckle. Before you begin, plan the composition, noting how big the drawing will be and where you want to position it on the paper. Keep this area in mind as you create your wash, leaving it pale and as free of paint as possible. See the example below for how this might look once you have your drawing in place.

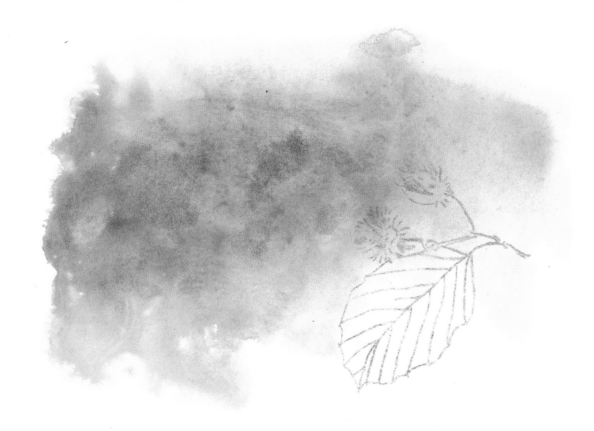

STEP TWO: CREATING YOUR LINE DRAWING AND TRANSFERRING IT TO THE PAPER

To keep the paper clean and not disturb the watercolor wash, create your outline drawing in graphite. Begin with the big picture shapes and then refine the contour lines and add in any details that will help you once you transfer the drawing. (If you need to revisit the steps of creating a drawing in graphite, see Graphite Project: A Single Pear [page 22].) Use the method of your choice to transfer the outline to the watercolor paper, positioning it where you wish the drawing to be. I used the tracing paper transfer method to transfer my line drawing onto the watercolor paper. Note the amount of detail I chose to include in my line drawing.

STEP THREE: FILLING IN THE FORMS

For this step, paying close attention to your reference image, fill in the mid-tone layers with graphite, always keeping in mind the *direction of form*. Notice how I have left some white space where the veins are on the leaf and how I filled out the form of the nuts, not adding in any details yet, but providing the mid-tones and shapes of the parts of each leaf, going a bit darker where necessary. At this stage, it's most important to block in the shapes of each part of the subject, not worrying about detail just yet. Use a very sharp HB pencil. (Refer back to Graphite Project: A Single Pear [page 22], if needed.) Remember that this layer is all about losing the outlines, so we can begin to create the illusion of roundness.

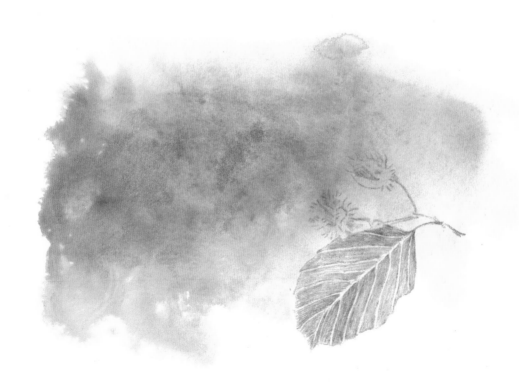

STEP FOUR: ADDING TEXTURE AND CONTRAST

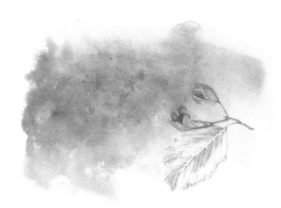

Now, we want to begin to add contrast and texture to the drawing. Paying close attention to the reference, use an eraser to lift out the areas of lightest value. Then, using a very sharp 2B pencil, add areas of darker values. Always keep in mind the direction of form and the textural qualities that you see on your subject, especially the tiny sharp spurs on the nuts and the veins on the leaf. Notice how I tightened up these areas quite a bit, after using a kneaded eraser to lift out the lightest shapes I saw in the reference image. Remember that you can adjust the value of your marks by using more or less pressure on your pencil, but keep a light touch in general.

You can always refer back to the graphite chapter (page 17). The goal for this step is to create depth and contrast between dark and light and to begin to give the subject the illusion of texture and details, where you notice it on your reference image.

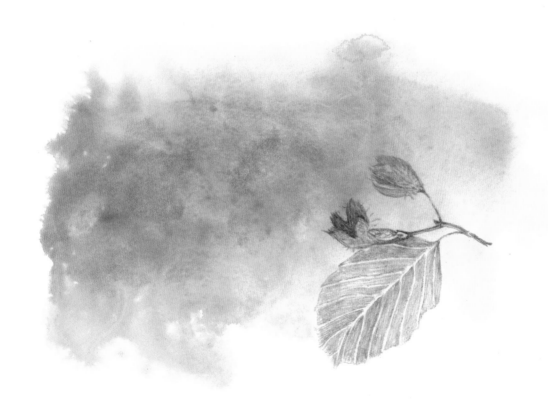

STEP FIVE: FINAL DETAILS AND DARKEST DARKS

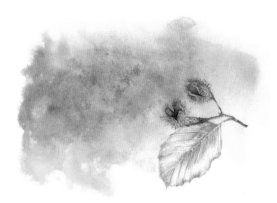

In the final stretch, compare your drawing to your reference image, noting areas that might need to be darker or lighter. Make those adjustments as needed and pay special attention to the very darkest areas. For graphite, use a well-sharpened 5B pencil for the smallest, darkest details.

These tiny additions of darkest values, details, and the transitions between them are what really give our drawings that sense of roundness and refinement. For this graphite drawing, consider where you might want to use a tortillon or blending stick to soften transitions or even a 4H pencil to create the smoothest transitions between dark and light. This is not always necessary, but keep in mind that the smoothness of transitions is one quality that gives the illusion of roundness and detail in realistic drawings.

The very last step is to add the fine markings you see on the leaf using a very sharp HB pencil and stippling marks or intuitive mark making to give the illusion of the surface texture of the leaf. Keep your touch delicate and subtle.

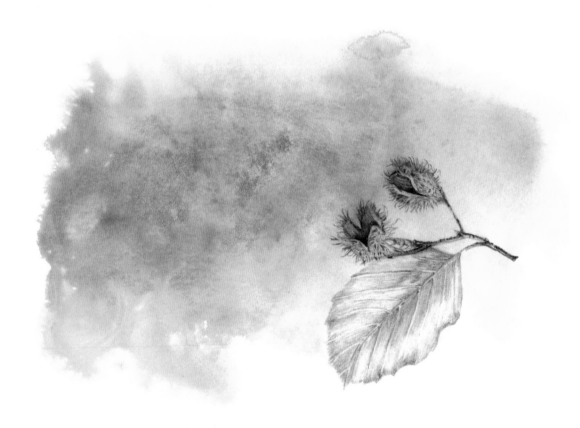

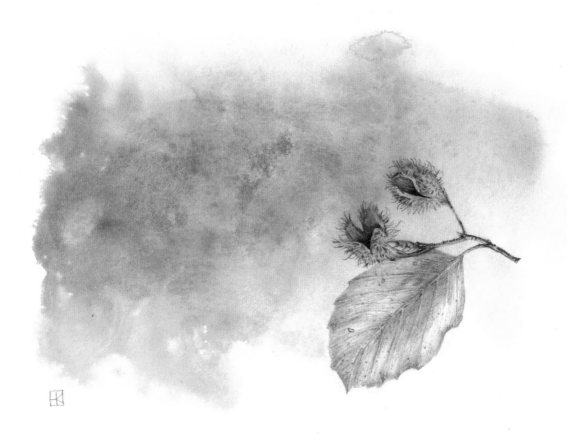

THE FINISHED DRAWING

The beauty of this drawing lies in its simplicity. The juxtaposition of the finely detailed drawing against the expressive and dreamy watercolor background can have a myriad of applications across a range of subject matters. I hope you will try many combinations of colors and subjects using these enjoyable techniques.

Ink and Watercolor Project: Autumn Treasures

Ink and watercolor can be an exquisite pairing. In this project, the fine detailed lines of pen and ink become the structure for loose colorful washes of pigment, giving a life-like quality to our realistic depictions of treasures from the natural world. The reference image has a grouping of many autumnal subjects from nature. Choose three that you would like in your composition, create line drawings of each on a sheet of paper, and then cut them out. On a piece of copy paper, arrange them in a composition that is pleasing to you and adhere them to the paper with a glue stick. This will become your reference image. I chose the oak leaf, the largest of the mushrooms, and the chestnut still in its spiky shell.

For this project, we will be making our initial line drawing in graphite and then use a waterproof black or brown ink to make a detailed drawing, following the same series of steps as in Pen and Ink Project: Pine Cone and Bough (page 56). Once complete, we'll use watercolor techniques to bring our realistic drawings to life. As always, refer back to the

Graphite (page 17) and Pen and Ink (page 49) chapters as needed.

STEP ONE: THE LINE DRAWING

Once you've settled on your three elements and have arranged them in a composition on a piece of copy paper, create a line drawing, adding just enough detail to capture the separate shapes within each subject. Transfer this drawing to a 9 × 12 inch (23 × 30 cm) sheet of hot-pressed watercolor paper, either taped to a drawing board or attached to a watercolor block.

STEP TWO: FIRST LAYER OF INK AND FILLING IN THE FORMS

The first layer of ink creates the boundaries of the drawing and replaces the pencil lines. This first outline should not be too dark, so a dilution of 1:5 ink to water ratio is ideal. It is very important that your ink is waterproof when creating a mixed-media drawing with watercolor. I used an acrylic ink in a transparent raw umber hue and diluted it with water in a shot glass. Using your dip pen with metal nib, create the outline as depicted in the image, referring to the reference image to make note of where the subject is dark for a strong line and where to use a broken line or stippling for lighter edges.

When this first outline layer is dry, begin to fill in the forms. You can refer back to the Pen and Ink chapter (page 49) to refresh, but, in general, fill in the forms using directional hatching or stippling for more subtle shading and texture to convert the contour of each shape within your subjects.

When using watercolor on ink drawings, we do not need to fill in the lighter areas. Instead, focus on the areas of darkest values to create a sense of roundness without filling in the entire form. Notice how I used stippling on the smoother areas such as the leaf

and mushroom cap, and then hatching for the directional lines on the mushroom stem, and cross-hatching for the deep recesses in the chestnut. I used more intuitive marks to create the illusion of the furry texture of the outer chestnut. Always remember that we want to really see our subjects, using our mark making decisions to create the illusion of the textures we see, without trying to copy each and every line and detail. This gives us a more poetic image that is unique to each of us.

The goal is to lay down these directional hatch marks first in a light layer (1:5 ratio, ink to water) and then to cross-hatch with a darker value of ink (1:3 ratio ink to water). These steps will leave us with a drawing that shows the beginning of the illusion of roundness—always our goal when creating realistic drawings no matter what medium we are working in.

Study the reference image to understand the level of hatching and stippling that should be added during this stage. We want the watercolor to have the center stage in our drawing, with the basic forms and shading provided by the ink. When this layer is complete, allow the ink to dry thoroughly and then use a kneaded eraser to gently remove any pencil marks still visible.

STEP THREE: ADDING IN THE DARKEST DARKS FOR CONTRAST

Before we apply watercolor to our drawing, we want to make sure that we have represented the darkest areas of contrast accurately. Squint your eyes and study your reference closely, noting where the very darkest areas occur. Using full-strength ink, add in these very small areas of darks using stippling (most common) or very slight hatching or intuitive marks. Often, these areas are very small, but they provide an important refinement in realistic drawings. Note in the image where I have added some of the very darkest marks.

Allow the drawing to dry completely before moving on to the next step.

STEP FOUR: WATERCOLOR WASH FOR THE LIGHTEST VALUES

Note: Please read through the remainder of this project before you begin.

Adding a wash of color to realistic drawings can bring to them to life in a completely different way. The first step is to choose your palette, based on your reference. For the subjects in our project we need only a few colors:

- A warm yellow such as new Gamboge, Indian Yellow, or Winsor Yellow Deep
- A warm brown such as burnt umber or a mix of warm red, blue, and golden yellow to achieve a similar hue

- A deep brown such as sepia or a mix of blue and orange to achieve a deep brown
- Several shades of green, which can be achieved by mixing different blues and yellows
- A pale milky ecru that can be mixed with brown and a touch of blue that has been diluted to a pale tea wash for a hint of color

You will also need a glass of clean water, paper toweling to wipe your brush, a size 2 pointed round brush, and a size 6 or 8 pointed round brush.

In watercolor, we begin with the lightest hues first. We can always build color to a darker value, but it's very difficult to bring a dark color back to a lighter value. For my project, I began with a warm yellow, using three different dilutions. A darker value (less water) for the veins on the leaf, a middle value (a bit more water) for the bottom half of the mushroom cap, and a very pale wash for the paler sections of the chestnuts.

For the leaf, I used a number 2 pointed round brush to very carefully add the darker warm yellow to the veins. For the mushroom cap, I used a number 6 pointed round brush to paint the middle value yellow across the bottom half, using a clean damp brush to soften the edge so it fades into the upper area without a line. I then used the number 2 pointed round brush to put a pale wash of creamy yellow on the lighter areas of the chestnuts.

Study your reference to find the palest values of color and begin there. Once complete, allow this layer to completely dry before moving on.

STEP FIVE: WATERCOLOR LAYERS— ADDING THE MID-TONE VALUES AND CHARGING IN THE DARKS

Next, we'll add a wash of watercolor to every other part of the drawing, using a mid-tone value. We adjust the value of watercolor by the amount of water we add to it. The more water we add, the paler it becomes. I suggest making a page of test swatches, mixing the colors you'll need for your subjects and trying varying amounts of water until you arrive at the mid-tone value of each hue. You will then do the same to create the darker values you see in each part of your subjects.

Let's look at the leaf as an example. For the leaf, I created a wash of burnt umber mixed to the mid-tone value and another mixed to the darker value of brown that I could see in the reference image. If you look at the reference, most of the leaf is in the mid-tone burnt umber range, with a few areas of darker brown. The mid-tone burnt umber mix is painted over the entire leaf, carefully avoiding the yellow veins. I used a number 2 pointed round brush and painted each section of the leaf, moving slowly around the veins. For the darker areas, immediately after painting each section, I picked up a small amount of the darker brown paint and dropped it into the wet paint, just a touch, so that it charged in and created the illusion of texture and color variation. By working each section in between the veins separately, it is easy to avoid painting over the bright yellow veins.

For the mushroom cap, use the same burnt umber mixes and the number 6 pointed round

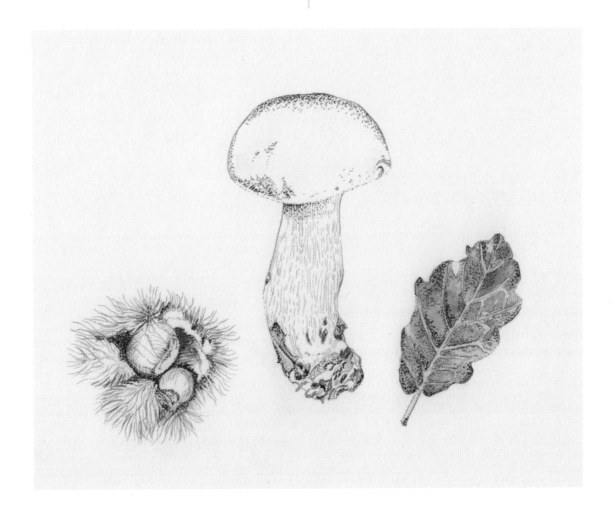

brush. Begin with a water glaze, painting the entire mushroom cap with a wash of clean water, making sure to remain inside the lines and to create an even glaze of water so the paint can move freely. Once the water glaze is on the paper, using your reference image as your guide (always!), begin at the top of the mushroom cap and apply the mid-tone burnt umber, stopping a little above the bottom of the cap. Allow the paint to creep into the yellow area; it will stop short of the lighter, bottom edge. Then, pick up some of the darker burnt umber mix and drop it into the wet paint along the very top where the mushroom cap is darker. Refer back to Layering (page 74), if needed. This technique creates soft color and value shifts and creates the illusion of roundness.

Clean your brush, dry it, and then use the tip of the brush to clean up the edges of the mushroom cap.

For the stem of the mushroom, mix a very pale, milky ecru color as noted previously. Apply it to the entire stem evenly.

The chestnuts are worked in two stages: first, adding a layer of mid-tone burnt umber on the actual brown nuts; then, dropping in a bit of the darker burnt umber mix where you see the darkest values on your reference image. This needs to dry completely before moving on to the furry-textured outer shell.

When the chestnuts are dry, mix a light spring green as close to the color of the furry chestnut shell as possible. You can use a lemon yellow with a touch of warm blue to get a fresh spring green. Also, have a bit of the burnt umber mix handy on your palette. Always remember to pay close attention to your reference throughout every step of a project.

Using a number 2 pointed round brush and a very light and feathery touch, paint the furry chestnut shell with the light green mix using short, feathery strokes in the direction of form. Pay close attention to the very edges and allow those to remain just as ink lines now and again. Once you have the green sections painted, use a touch of the burnt umber to add a soft flick of color at the base of some of the little spikes as in the reference. Finally, mix the burnt umber with the spring green and paint the inside of the chestnut shell, leaving bits of white paper showing through as needed.

Let your painting completely dry before moving on to the final step.

STEP SIX: ADDING CONTRAST AND THE FINAL DETAILS

Now is when we take a good look at our painting, comparing it to the reference image. Where do we need more contrast? What areas of the painting look flat and need more roundness? We will now go over each subject in our composition to make sure we have captured everything necessary to give our drawing presence.

This step is about refinement. Take a close look at each subject in the composition. Do you need any darker marks on the leaf? Should you touch up the bright yellow veins? The mushroom might need to be darkened a bit where the cap casts a shadow at the top of the stem. Look closely at the bottom of the stem. Using the same colors as before, I added more contrast and deepened the browns. I also added a pale mix of the green and burnt umber to the stem in small strokes where I saw markings in the reference. On the chestnut, I added a bit more of the same green and burnt umber mix to the base of the green spikes where it was needed, and I deepened the contrast of the dark brown on the nuts. I also added a bit more of the green mix to deepen where there might be shadows within the green spikes. You can study the image of the final drawing to see where I added these final details.

This step is very specific to your painting. It is a chance to really define the areas of highest contrast, refine any areas that might not have clean edges, and add any last details that you feel will make your subject unique. Take some time to comb over each element and add those finishing touches using a number 2 pointed round brush.

THE FINISHED DRAWING

This style of ink with watercolor has a true illustration feel, but with a natural and refined elegance. It is well-suited toward more delicate, natural objects. I hope you will try several combinations from the reference image and also use this technique to portray some of the small treasures you might find in nature.

Graphite and Watercolor Project: Chickadee on a Branch

When we think of watercolor, it's common to imagine loose and expressive washes that are very painterly. Watercolor can also be used as a precise method of drawing in a very realistic style. Think of the fine details and realism of botanical art or natural history illustrations that are created with watercolor.

In this project, we'll use our graphite skills to create an outline of a chickadee on a branch and then bring our subject to life in full color with watercolor. There are so many ways to approach this style of drawing with watercolor, and the techniques I'll share are the ones I rely on for all of my depiction of birds and botanical subjects.

Let the reference image of the chickadee be your constant guide. Study it well at each step along the way. Remember, our main focus is

to really learn how to see our subjects and then to use tried and true techniques to help us portray the illusion of our subject in a realistic way, on paper. We don't need to be a slave to every minute detail; however, we do need to use our reference as our ally. Take each step slowly and surely and you will be drawing with graphite and watercolor in a realistic style that can be used to portray all kind of subjects.

TOOLS AND MATERIALS

- Hot-pressed watercolor paper in 140 lb (255 gsm), either taped to a drawing board or in watercolor block form: I have used Stonehenge Aqua paper in hot press block, size 9 × 12 inch (23 × 30 cm). It's perfect for watercolor and graphite in fine detail.

- Assorted watercolor paints, artist-grade quality: I used Buff Titanium, Raw Sienna, Burnt Sienna, Payne's Gray, Burnt Umber, Sepia, and French Ultramarine. Most of these are standard in a basic watercolor set. I will include mixing ideas throughout, if you are using a split primary limited palette.
- Watercolor brushes in pointed round, sizes 8 and 2: If you have a size 0, it may be handy for the finest details.
- White ceramic mixing plate or palette for mixing paints
- Paper toweling to wipe brushes
- A jar of clean water
- An HB pencil
- A kneaded eraser or other clean eraser suitable for graphite
- Sketching paper to create initial drawing, which can then be transferred to the watercolor paper

STEP ONE: CREATING AN OUTLINE DRAWING IN GRAPHITE WITH THE BIG PICTURE BLOCK-IN

As always, you can refer back to the Graphite chapter (page 17) to refresh your memory on the steps needed to achieve a precise line drawing of your subject. Using a very sharp HB pencil and a piece of sketching paper, find the basic shapes of your subject and draw them on the paper. Use the example shown as a guide.

STEP TWO: REFINING THE LINE DRAWING

Paying close attention to the reference image, use an HB pencil to refine the outline of your subject. Use an eraser to remove any unwanted lines and redraw the lines as needed. I suggested creating your drawing life-sized to fit nicely within a 9 × 12 inch (23 × 30 cm) piece of paper. Use the example shown as your guide. Notice how much detail is depicted in the line drawing. We want just enough to remind us of specific areas of details, yet no shading that might muddy the watercolor.

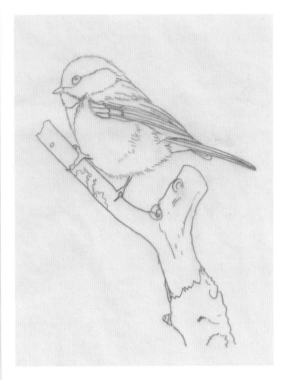

Once your line drawing is complete, use your transfer method of choice to transfer your drawing onto the hot-press watercolor paper. Your drawing is now ready for the application of watercolor.

STEP THREE: PAINTING THE LIGHTEST VALUES

In watercolor, I tend to work from light to dark, and just as with the mid-tone layer in graphite drawings, I want to cover the entire image with a layer of paint. In graphite, we begin with a mid-tone layer and reveal the lightest areas with an eraser. Since watercolor cannot be erased, it is best to begin with the palest wash of color.

For this subject, there are three main areas/hues of color on the bird and branch:

- A pale gray for the bird's head, wing feathers, tail, and for the bottom section of the branch: I created this with a very watered-down wash of Payne's Gray. You could also mix French Ultramarine with a touch of warm red and warm yellow until you achieve a neutral gray.
- A pale ecru/tan for the bird's body: I used a mix of Raw Sienna, a touch of Sepia, a very small touch of French Ultramarine, and plenty of water. You could also use Buff Titanium watercolor or a mix of warm yellow with a very slight amount of cool red and warm blue to achieve a pale ecru/oyster white.

- A pale golden tan for the branch: I used Raw Sienna with plenty of water. You could also use a watered down mix of warm yellow, warm red, and a very slight touch of warm blue to mute it.

Notice where the washes are placed on the line drawing and how very pale they are. This step maps out the main areas of color without committing to darker values just yet.

For the bird, use the tip of the number 2 pointed round brush to create light strokes of color in the direction of form. Use the ecru mix where you see white or buff hues and the gray mix for black or gray areas. Keep your strokes light and always mindful of direction of form.

For the branch, use the larger size 8 pointed round brush to fill in the branch with the pale golden tan mix. Always keep in mind the direction of your brushstrokes: direction of form. Toward the bottom of the branch, introduce the gray mix where you see a shift in color and then continue on with the golden tan mix to finish.

In this step, you will also create the first layer of the bird's eye. Pay special attention to reserving the white spaces for catching light in the bird's eye. Use a darker mix of Payne's Gray (or warm blue and warm red with a touch of warm yellow) and the very tip of a number 2 pointed round brush to depict the darkest values in the bird's eye. This is the only place where I begin with the darkest values. I find that creating the eye in the very beginning gives the bird the spark of life. If the eye fails, I begin again with a new drawing. If I wait until the end and the eye fails to come alive, I've lost much invested time.

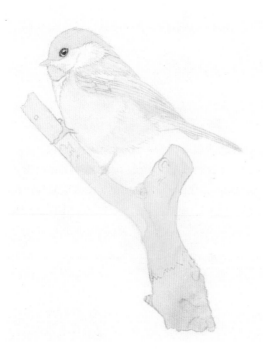

STEP FOUR: FIRST MID-TONE LAYER

When using watercolor over graphite in a realistic drawing style, we want to gradually build up layers of color using appropriate brushstrokes in direction of form. In this step, we continue building layers with a mid-tone value of each of the color mixes we have previously used or as we see in our reference.

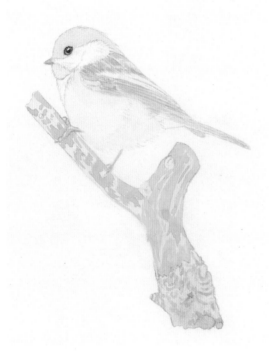

Begin with the branch by mixing a mid-tone value wash of Burnt Sienna. You can also mix a warm red with a bit of warm yellow and a very small touch of warm blue. Use a number 8 pointed round brush and use your reference image as a guide. Create light brushstrokes of Burnt Sienna in the direction of form, depicting the mid-tone markings seen on the reference image. Notice in the example shown how these markings are not too dark (we will add the darker values later) and carefully follow direction of form. The marks may stray in size and shape a bit, but applying them in direction of form is key. This supplies not only texture and color, but also provides a way to depict form and roundness. It gives the branch a realistic structure and sense of growth and movement.

Where the branch changes texture and color toward the bottom, continue with a mid-tone gray mix. Again, I used a Payne's Gray, but you can also use the same mix as in the first layer, adjusting the amount of paint added to create a darker value.

Once the branch is complete, using a number 2 pointed round brush, begin to add more of the gray mix to the areas of the bird that are of a mid-tone value, including the eye and the feet. Study your reference image as well as the example shown.

Again, use fine brushstrokes in the direction of form. For example, the strokes along the wings would be long, fluid, and thin, while the strokes on the upper mantle beneath the head would be short and feathery. We are always trying to use our brushstrokes to mimic what our eyes see in texture, form, and color.

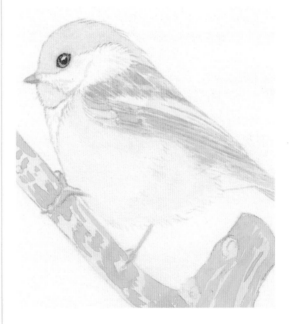

Next, mix a slighter darker version of the ecru color and follow the same steps for the body of the bird, adding a touch of Burnt Sienna to where you see it on the upper portion of the body.

STEP FIVE: THE SECOND MID-TONE LAYER

When the previous layer is completely dry, it's time to add a bit more contrast with a second mid-tone layer, just slightly darker than the last. You could obviously skip this step, but in watercolor, these incremental layers are what build roundness and texture and realism into our work.

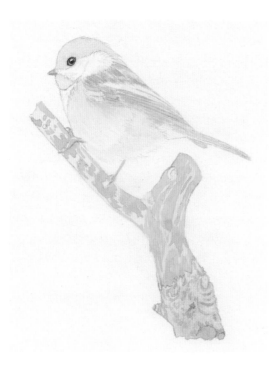

Enliven the color from the previous layer and make each a bit darker—not as dark as the very darkest areas in your reference, but somewhere in between. Using the very tip of a number 2 pointed round brush, follow the same process as before, but narrow in on the next darkest values that you see. As always, follow direction of form with your brushstrokes. In this layer, we really begin to refine the details of our little bird. Take your time, allowing your eyes to study every area of the subject. (Don't forget the tiny legs and feet!) This is slow work and so enjoyable. When we really take the time to see our subjects, we learn so much that we did not know before.

Allow the painting to dry completely before moving on.

STEP SIX: ADDING HUE AND SHADOW WASHES AND FINISHING THE BIRD'S HEAD

It's time to address the larger areas of shadow and hue in our subjects. Notice on the reference image how the upper section of the bird's shoulder area (the mantle) has a warm gray cast to its color. Notice the roundness of the bird's belly and the darkness of the area just below the point where the wings meet the body. Also notice the deep black of the bird's head and neck. These areas can be lightly washed with color to give them more depth and refinement of color. The previous layer needs to be completely dry.

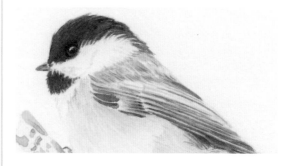

Let's begin with the mantle area of the bird's shoulder. Mix a very pale wash of warm gray using warm blue and then a touch of warm red and warm yellow. This should be a pale warmer gray, barely a hint of color. Using your number 2 pointed round brush, carefully apply a light wash of this color to the upper area where you notice the warm golden/greenish-gray cast to the bird's feathers.

Now, take a look at the pale belly of the bird. Whether or not we see a shadow on our reference or not, here is a place where we might need to use creative license. To give our subject the illusion of roundness, there needs to be a subtle transition of value, even if our reference shows the area of white. Using a very pale wash of a cool gray mix from previous steps, lightly add a line of this pale gray where the bird's body would curve away from you: the area where the head meets the body, the

area where the body meets the wings, and the lower edge of the body. Use the softening technique to gently transition the pale gray to the pale ecru of the body. This is a subtle step, but very important. Once done, use this same pale gray wash to gently add a smooth layer over the wing area, toning down the bright white of the paper just a bit.

Next, we will add a wash layer to the branch, making the color richer and unifying all of the layers we already have in place. Use a pale wash of Burnt Sienna for this layer, gently covering the entire branch, except for the grayish area at the bottom. While this layer is still wet, drop in a mid-tone wash of deep brown to the areas on the branch that appear darker in value, especially where the bird is casting a shadow around the feet. The wet-on-wet technique of charging in color will create soft transitions between dark and light and will not affect the details you added earlier. Again, use a gentle application, barely touching the brush to the paper so as not to disturb what is underneath. Continue with your gray wash to add a layer onto the gray area of the branch, toward the bottom.

Now that our wash layers are complete, it's time to add a layer of black to the chickadee's head. Use a very strong mix of Payne's Gray plus a bit of Burnt sienna or mix a deep black wash with any three primary colors. Then, paying close attention to the direction of form, use the very tip of the number 2 pointed round brush to add in the dark, yet fluid, black mix, with short feathery strokes. Be very mindful of the edges, paying close attention to the reference image to observe the texture of the tiny black feathers and the direction they take. Add an extra layer of black right around the eye, suggesting the boundaries of where the black feathers meet the dark eye.

Allow this layer to dry completely before moving on.

STEP SEVEN: THE FINISHING TOUCHES

In the final layer of a realistic watercolor drawing, it's all about looking over our work to find and enhance the finest details. Use a number 2 pointed round brush for this or if you feel you need a smaller brush, a size 0. I tend to prefer a number 2 because it holds more paint and can achieve a more fluid line. One trick is to always dab the excess paint from the tip, making sure the brush is coming to a fine point, before using it to apply fine lines to the paper.

Make sure you have a very dark mix of all the colors you used in the drawing up to this point. Beginning at the top of the subject, compare your drawing with your reference image, making note of any place that could use some depth or darker values of very fine details. Also, note any place that might seem like it needs some intuitive markings to depict texture such as on the branch. Study the sample of the final drawing to see where I have added those finest, dark details and intuitive marks.

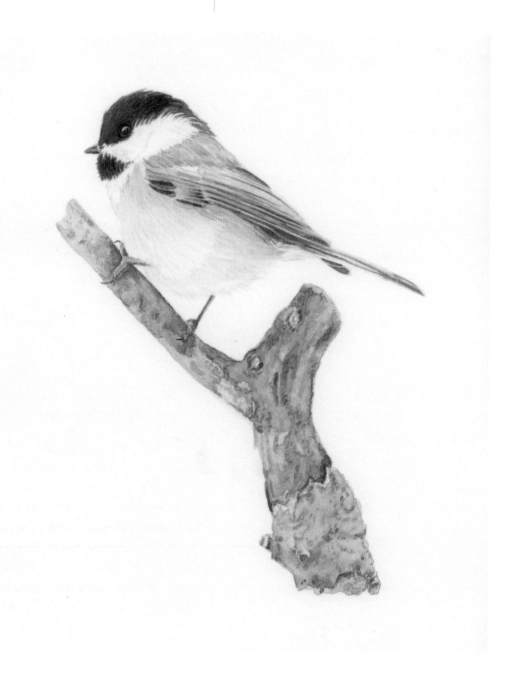

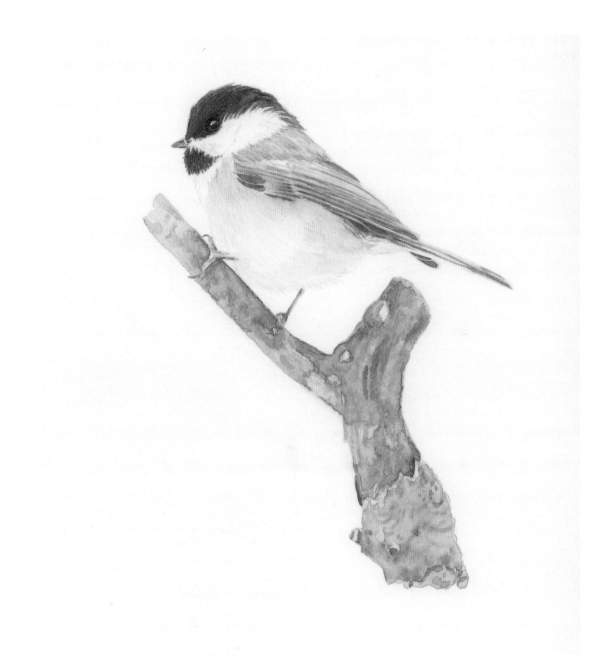

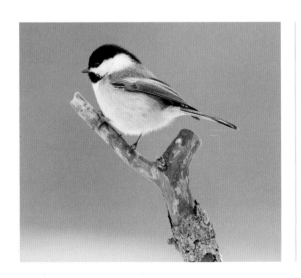

THE FINISHED DRAWING

From detailed outline drawing to finished bird, the slow method of gradually building layers—from light to dark, from broader stokes of light washes to the finest details with the very tip of the brush—allow us to create the illusion of realism no matter what our subject is. I hope you will try these techniques with many different natural subjects that you wish to portray with graphite and watercolor.

A FINAL PROJECT—STILL LIFE
IN BOTH GRAPHITE AND INK

We've learned a lot about honing our ability to see subjects along with the techniques to help us document what we see with many mediums: graphite, charcoal, ink, and watercolor. One question that I'm often asked is "How do you decide which medium to use when creating realistic drawings?" For me, this has to do with my emotional response to the subject I wish to portray, but also with the unique characteristics of the subject. Is my subject full of linear surfaces, such as the pine needles on a bough? Then, the fine lines I can achieve with pen and ink would be a great fit. Does my subject exude a soft sense of roundness, subtle coloring, and fine textural detail? Then, graphite would be an excellent choice, such as with the pear. Do I want to suggest dramatic lighting on a very simple subject? Nothing can achieve dramatic lights and darks with subtle shading like a reductive charcoal drawing, such as in the Charcoal Project: Turnips (page 38). And then there is watercolor, which can bring brilliant color to drawings either as a dreamy background as in the Graphite and Watercolor Project: Beech Leaves and Nuts (page 76) or as a way to achieve fine detail and life-like color, as in the Graphite and Watercolor Project: Chickadee on a Branch (page 88). So many choices, but in the end the choice is yours.

Our final project is actually two projects created from the same reference image. First, we'll make a realistic drawing in graphite, then another in pen and ink with wash. I chose a simple still life that includes a man-made object. The way I depict man-made objects in my drawings is to use less focus on them, making the natural subjects the focal point. This is my own personal aesthetic, but I find it effective. In the reference image, we have a simple white vase that has a real sense of roundness, but no texture or other detail. This lends itself to subtle transitions with graphite or dreamy washes with ink. No other detail will be necessary. However, the branches of leaves and flowers can be depicted with fine details, making nature the focal point.

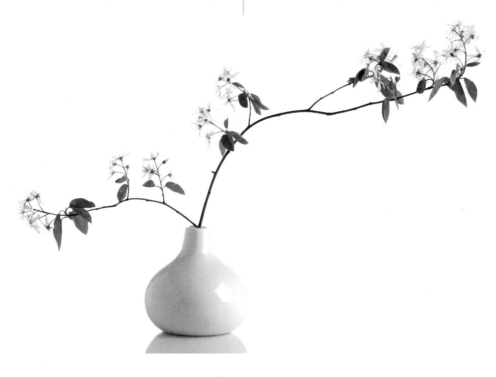

Still Life in Graphite

Let's use some of the skills and techniques we've practiced to create a very refined still life of a flowering branch in a white glass vase. I chose this image for its wide variety of textures, from the shiny and reflective glass to the velvety white petals to the textured foliage and branch. This is a perfect subject to bring many techniques to one project and requires a refined and delicate touch.

TOOLS AND MATERIALS

- Well-sharpened graphite pencils in 5B, 2B, HB, and 4H
- Pencil sharpener
- Kneaded eraser and sharpened stick eraser
- Feather or brush to dust off paper as needed
- Vellum-finish drawing paper in size 9 × 12 inch (23 × 30 cm), such as Stonehenge White

STEP ONE: THE BIG PICTURE BLOCK-IN AND LINE DRAWING

As with all drawing projects, begin on a piece of sketchbook paper by creating a big picture block-in. Notice the shapes you see in the vase, an oval for the base with a small square for the neck. Pay attention to the proportions of each and how they relate to one another and to the composition as a whole. Also, notice the area of highlight on the vase and make a suggestion of it in your line drawing.

For the branches, use fluid lines, in segments, as they extend from the base to the tip. You don't need to be exact, but create likenesses of each segment of the two main branches and the places where smaller twigs branch out and support the leaves and flowers. Notice in the sample drawing how the flowers are not drawn, but the leaves are. This allows us to draw the flowers very lightly where they fit in, as the final step, even using a blending stick for a very soft suggestion of line without committing to a hard mark that would need to be erased.

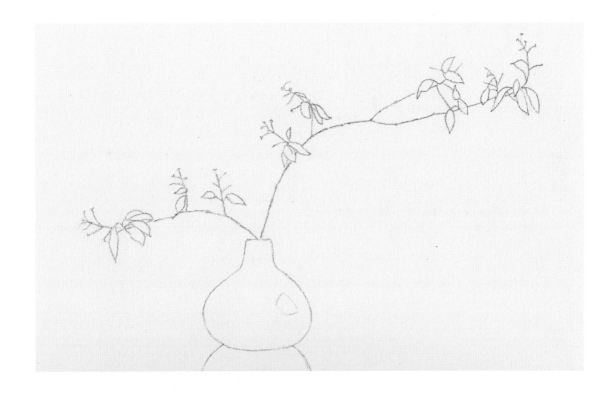

This exercise will test your ability to create small, fine shapes and detail. We tend to think that bigger subjects are more difficult, but often, it is the smallest subjects that test our skills the most. It's important to keep your pencils at their sharpest when drawing small objects. It will make your job much easier.

Study both the reference and the sample drawing for an idea of how much detail to add to the line drawing. Adjust your marks as necessary and once finished, use your transfer method of choice to transfer the line drawing to a clean sheet of drawing paper. Save the sketchbook drawing for use in the next lesson as well.

STEP TWO: LOSING THE OUTLINES BY CREATING A MID-TONE VALUE LAYER

In this step, use a well-sharpened HB pencil to create a mid-tone value layer of graphite in the direction of form. If there are any areas of white highlight, leave the paper white. Also, do not fill in the white flowers yet, but do make marks to suggest the sepals where you see them and also fill in the form of the branches. Study the example to see how I've used direction of form and to notice where I've left the paper white, in comparison to the reference image. Also make note of where I used creative license to simplify the composition of leaves where necessary.

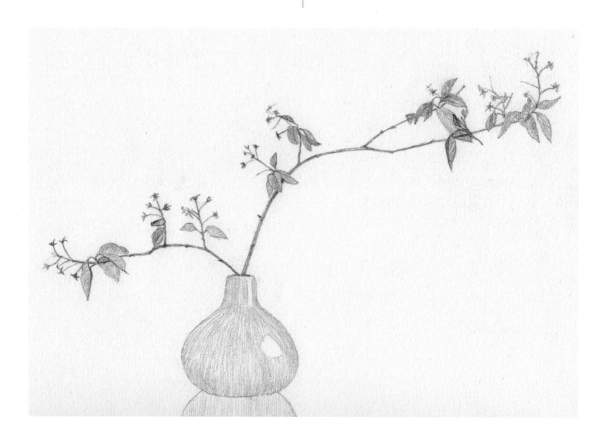

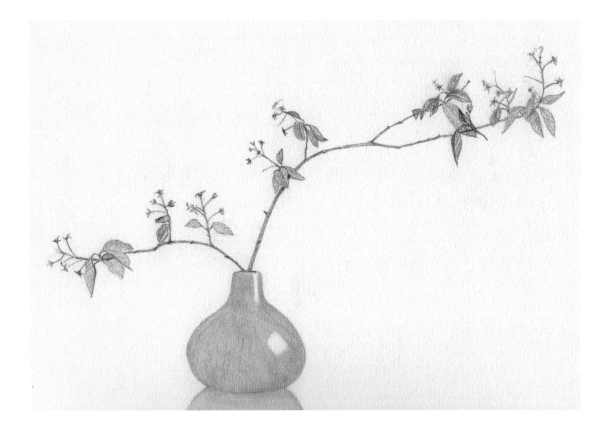

STEP THREE: BLENDING TO CREATE AN EVEN TEXTURE

This step addresses the man-made object in our reference image, the white vase. To create the illusion of its smooth and reflective surface, we'll use a tortillon or blending stick with the lightest pressure possible. Pay close attention to the reference image and follow the direction of form. Start at the top of the vase and gently smooth the graphite with the tip of the tortillon in the direction of form until you have an even texture all over. Do not press firmly or embed the graphite into the texture of the paper. Think of your blending tool as a feather grazing over the surface. Take a look at the example to see how this should appear when complete. Remember to keep the white areas, as seen in the reference image, free of any graphite.

STEP FOUR: REVEALING THE HIGHLIGHTS

Now, it's time to reveal the light. You will need your kneaded eraser as well as a stick eraser with a sharp point. For the Tombow stick erasers, cut the end into a chisel-tip with an X-Acto knife. For pencil-style stick erasers, use a pencil sharpener. This is very helpful for tiny highlights on smaller subjects such as the leaves, if necessary, and for subtle lifting on larger areas. Use the kneaded eraser to delicately press and lift the graphite on the vase where you notice highlights on the reference image. The stick eraser is used for small areas of light everywhere else, including the top edge of the vase, and to blend between areas of dark and light. Experiment with them both to see how they best work for you, always using the lightest touch. Study the example to see how your drawing should look after this step, paying special attention the different values of light in the vase, the shapes formed by the highlights, and the lighter areas of the cast shadow.

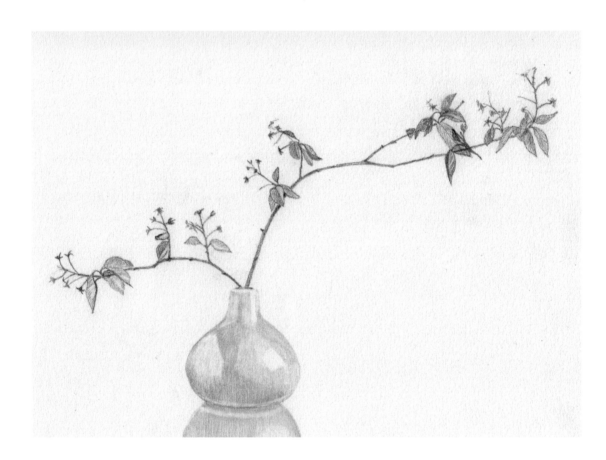

STEP FIVE: ADDING THE DARKS

Here, we begin to add the contrast to the leaves, branches, and the space where the vase meets the cast shadow. Again, this is delicate work, as our subject is so small. Using a very sharp HB pencil, begin to comb over the entire spectrum of leaves and branches, leaving the space for the flowers blank. Notice where the leaves are darkest and use the very tip of the pencil to mark in what you see, always following the direction of form. The branches need to be darkened over all, but pay attention to where they are darkest, especially at the areas where leaves create shadows on the branch and on the places where the branches join. This is slow and fine work, and I cannot stress enough how important it is to really see your reference and mimic what your eyes see with your pencil marks.

Once the leaves and branches are complete, create a darker area where the vase meets the cast shadow. Be soft but specific here. We will blend all together in the next step.

STEP SIX: THE DANCE BETWEEN DARK AND LIGHT

Once we have our lightest areas and darker areas in place, it's time to soften the transitions between the two. With your 4H pencil and very delicate pressure, blend these areas together on the leaves. It doesn't take much, but it's a very important step. Always think in terms of directional form and the balance between dark and light as you see it in the reference image. Study the example before you begin.

Once the leaves and branches have been blended, continue to use the 4H pencil to lightly blend the areas where dark and light meet on the vase. Use fluid and light pencil strokes, varying between light hatching, cross-hatching, stippling, circular motions, and intuitive marks. Imagine your pencil is a fine cloth and you are polishing the smooth white porcelain of the vase, always taking care to leave the brightest white highlights as the pure white of the paper and to subtlety darken areas where there is shadow. Take your time here and closely observe the reference image throughout.

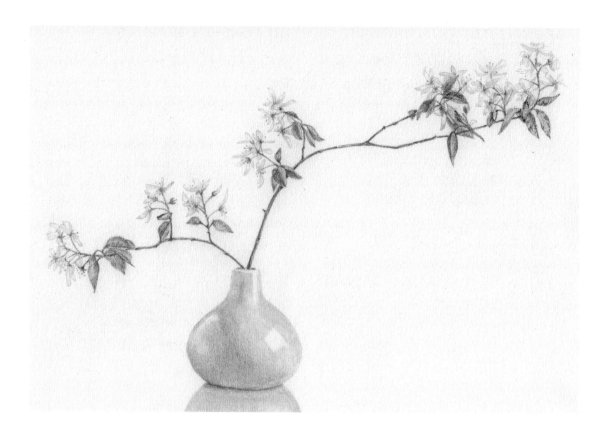

STEP SEVEN: THE WHITE FLOWERS

Before the final step of adding in the darkest details, we need to add the illusion of the white flowers. Illusion means that we don't need to be exact. Use creative license to add the petals where they fit into your drawing, but be true to the forms of the petals and how they are situated on each stem. You don't need to make a photographic copy, and it's fine to leave off petals if the area feels congested. It's never a bad idea to simplify the composition of the elements to make them better suited to a drawing.

White is rarely white, but when you're working in a monochromatic medium such as graphite you need to be particularly careful to not go too dark. For this step, use your 4H pencil and a clean tortillon. The idea is to lightly create the outline of the flowers using broken lines and stippling with the graphite. Then, use the tortillon to blend it into form.

Where the edges are lightest, use stippling, and where they are completely white, use a broken line. First, use the 4H to draw the outline of every flower and then go back and gently blend to mimic the forms and values that you see in each flower petal. This is also slow work, but meditative. Take your time as you work your way across every flower. You might also need to use an eraser to lift areas of branch or leaf where a white petal needs to be. Study the example to see how the flowers might look when finished. We each see things in our own unique way, and your flowers will be your own.

STEP EIGHT: THE FINAL DETAILS

The last step is about creating the areas of greatest contrast and making them really pop by using a very sharp 6B pencil and adding the tiny marks of darkest gray where we notice them on our reference image. These small, subtle marks will bring dimension to your drawing and truly bring it life. Squint your eyes when studying the reference image and notice where the darkest areas are. This is where we want to add small and intuitive markings, making sure to comb over the entire composition. Take a look at the finished drawing to see where I've made these marks.

THE FINISHED DRAWING

The more we draw, the better we see; and the better we see, the more honest, realistic, and poetic our drawings become. This drawing of the flowering branches is a testament to that. When we can accurately create the illusion of such tiny subjects, we're truly using our eyes and hands together. Next, we'll use the same reference image to see how to create a different kind of portrait of nature by using pen and ink and wash.

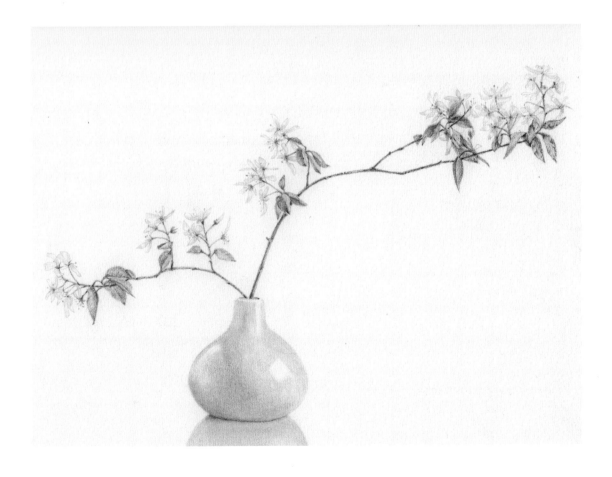

Still Life in Pen and Ink and Wash

For the final project, we'll use a different approach to the same subject of a vase with flowering branches. By using pen and ink, we can create the finely detailed leaves and branches. By using ink wash, we can portray the vase as rounded, smooth, and a bit expressionistic. I love the juxtaposition of richly detailed renderings with the dreamier, loose washes of ink. Again, we're working with fine detail on a very small subject, which challenges our rendering skills and delicate touch.

TOOLS AND MATERIALS

- HB drawing pencil for the initial line drawing
- Kneaded eraser
- Metal drawing nib and nib holder: I used a Manga G nib.
- Pointed round watercolor brushes, size 8 and size 2: If you have a size 0, it might be helpful.
- Chinese carbon-based drawing ink or other water-soluble ink: You can choose black or sepia, depending on your preference. I'll use black Chinese ink.
- Shot glasses or jars or other type of glass wells for ink
- Two glasses of clean water
- Paper toweling
- 100% cotton, sized drawing paper such as Stonehenge White in 9 × 12 inch (23 × 30 cm) or sized, hot pressed watercolor paper, preferably 100% cotton, in 9 × 12 inch (23 × 30 cm): You can either tape it to a drawing board or work from a block. I used Stonehenge Aqua Hot Press in 140 lb (255 gsm).

STEP ONE: TRANSFERRING THE OUTLINE DRAWING

Because you've already done the work of creating the outline drawing for the previous project, simply use that original drawing to create a transfer to the hot-press watercolor paper or sized drawing paper. Notice in the sample drawing how the highlights on the vase are included this time. You can simply add these with light pencil markings to your finished transfer.

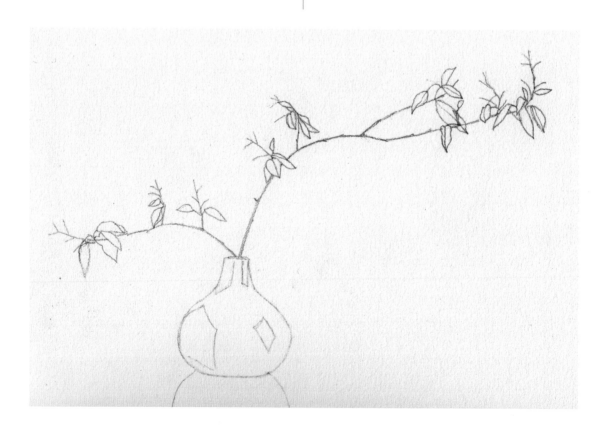

STEP TWO: THE VASE

Normally, I propose going over the entire subject step by step, but with this project, I suggest completing the vase in its entirety before moving on. The reason is that the vase is the trickiest part, and if we need to begin again, all is not lost. If I know that a certain component of a composition is going to be more difficult than others, I will often complete that area first so that I do not lose hours of work if I need to start over. We learn by our mistakes.

We'll use a heavily diluted ink and the fine point of a watercolor brush for the vase. A number 8 pointed round brush that comes to a fine point is perfect. Make sure you clean your brush very well after using it for ink washes. To begin, make three dilutions of ink to water in small shot gasses or a small palette dish with individual wells: 1:8 parts ink to water (very, very pale!); 1:6 parts ink to water; and 1:4 parts ink to water. The ink washes for the vase are very pale, and yet the ink version will turn out a bit darker than the graphite version. Still, we'll have the same illusion of a smooth, shiny ceramic surface. All brands of ink have different levels of darkness. If your dilution seems too dark, add more water.

Step A: With the pointed round brush and the 1:8 dilution of ink to water, carefully lay a light wash over the entire vase, avoiding

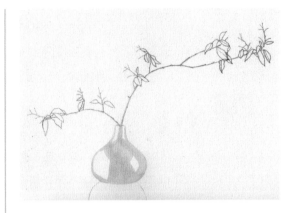

all of the highlighted areas that are defined in the pencil drawing. See the example for how this should look when complete. Allow this layer to dry *completely* and then use a clean kneaded eraser to gently erase all the pencil lines except for the lines defining the cast shadow.

Step B: Next, we'll add another wash over the entire vase, using the same 1:8 dilution, but this time avoiding only the two brightest highlights shown on the right side of the vase. Study the example to see how this should look. When the wash is complete, dip the tip of the brush into the 1:6 dilution and carefully drop just a touch of the diluted ink into the areas where you see shadow on the vase on the left side. Again, study the example to see where the 1:6 dilution was added. We're slowly creating the illusion of roundness.

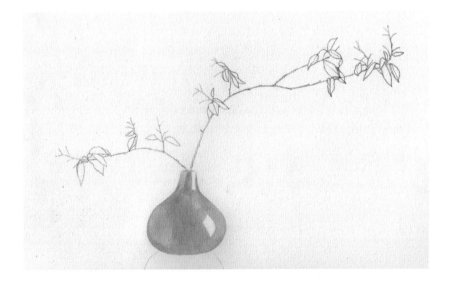

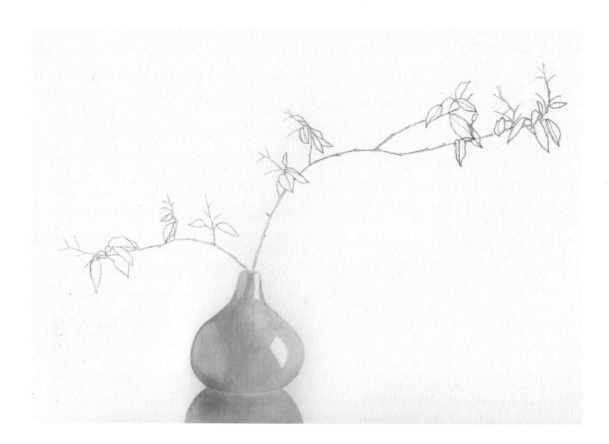

Step C: This is the final wash for the vase. We'll also create the cast shadow underneath it. Begin with a glaze of clean water over the entire vase, excluding the brightest two highlights on the right. We'll leave these as the white of the paper for maximum effect of shine, but will soften the edges at the very end of the project.

After the water glaze is in place, slightly tilt the paper so the ink works its way downward. Dip the brush into the 1:6 dilution and drop in very small amounts where you see the darkest areas of shadow. Let the ink pool at the bottom edge and then dry your brush and use it to wick up any extra wetness.

Next, dip the brush into the 1:4 dilution and draw a line along the bottom edge of the vase, being careful not to go over into the wet edge. Begin to pull the wash down and across the area of the cast shadow, allowing it to lightly fade as you move the wash away from the vase. Wick up any extra ink at the bottom with a damp brush and then lay the paper flat on the table again. Notice the area between the vase and the cast shadow in the reference. It's a bit wider and darker toward the left side. Drop in a bit more of the 1:4 dilution to create this additional darkness. Then, clean and dry your brush and lightly run the tip along the area where the vase meets the cast shadow. This will soften the two areas together and create a thread of light where the two areas meet. Allow the ink to dry completely before moving on.

STEP THREE: THE FIRST LAYER OF INK AND BROKEN LINES

Once again, our goal is to have a layer, light in value, over the entire image. We are basically creating the same outline drawing, but in a light value of ink. Once this is complete and is totally dry, we'll erase the pencil lines of the transfer drawing.

Use the extra light 1:8 ink dilution for the first layer. Keep in mind that different brands and types of ink have different strengths. Refer back to Creating Values in Pen and Ink. If your ink still seems quite dark at a 1:8 dilution, add more water until you achieve the correct value.

In making realistic drawings in pen and ink, be mindful not to create a hard or dark outline, especially when there are areas of the drawing with lost, or very light, edges. Do this by using the lighter value of ink and by using a very fine line, as well as broken lines and stippling. Refer back to the Pen and Ink chapter (page 49) if necessary.

Look at the reference image and notice where the leaves and branches have lighter edges. When we draw these during the first layer, we'll create this "light" by using broken lines, or even stippling, to avoid a strong outline. Look closely at the example shown to see how this might look. Make note of the thickness of the branches and stems. Use a more solid line on the darker edges and a broken line of stipples where lighter. We won't be adding the white flowers until the very end, but do work in intuitive marks, lightly, where you see the darker sepals of the flowers.

Begin to ink the transfer drawing by starting on the left side of the image if you are right-handed or the right side if you are left-handed. This will help prevent accidental smudges while the ink is still wet. Pay close attention to your reference image or subject while inking over the pencil lines, using broken lines and stippling whenever you come to a place that requires it. When finished, allow the drawing to dry for at least an hour before using a clean kneaded eraser to gently remove all traces of the graphite transfer drawing.

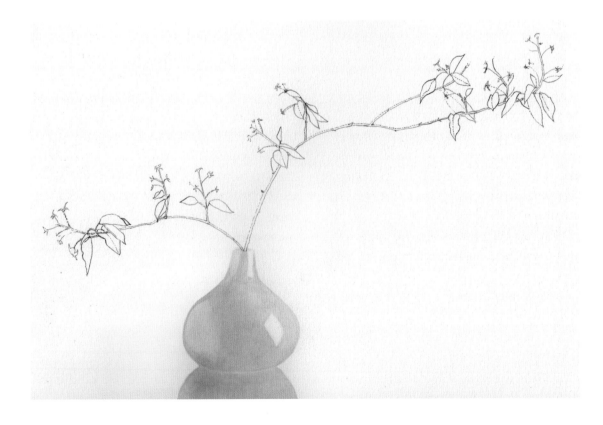

STEP FOUR: FILLING IN THE FORMS

It's time to fill in the forms using directional hatching and stippling to convert the contour of each shape. Our goal is to lay down these directional hatch marks, first in a light layer and then to cross-hatch with a darker value of ink. These steps will leave us with a drawing that shows the beginning of the illusion of roundness—always the goal when creating realistic drawings, no matter what medium we are working in.

For this step, create a 1:6 ink dilution in a shot glass or small jar and have another glass of clean water sitting next to it. You can also use the dipping method as discussed in Creating Values in Pen and Ink (page 53). You will also want some clean paper toweling to dab your nib on to remove excess ink. Paying close attention to the reference image, begin

to fill in hatch marks in the direction of form with a 1:6 dilution of ink. One reason that I prefer the dipping method is because it gives me more random variations in value, which I find pleasing, and I can easily take the ink to a lighter value if necessary. If you prefer a more uniform value, use a pre-made dilution of 1:6.

We are working only on the leaves and branches. Pay special attention to the areas where the sample drawing has the darker cross-hatching. Don't add in the darkest darks or fine details; simply fill in the contour of the outlined subject. The subject is delicate and small, so use a fine, delicate touch and work slowly across each leaf and section of branch, always remembering the direction of form. When these steps are complete, allow your drawing to dry completely before moving on.

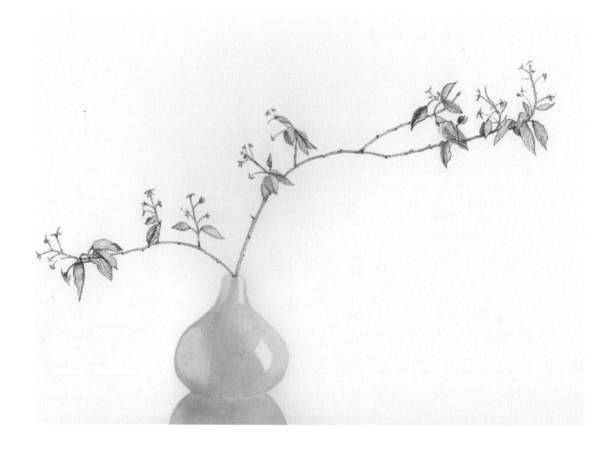

STEP FIVE: ADDING DETAIL AND REFINING CONTRAST

Now begins the dance between dark and light and the fine application of textural marks. As with the graphite version of this subject, our subject is quite delicate and small; our marks will be, also. This can seem insignificant, but it's what truly defines a realistic drawing with a sense of presence over a simple drawing made with hatching and basic contrast. We want to use our eyes to really see our subject and then to use our drawing tool as an extension of our eyes to intuitively make marks that create the illusion of what we see. This is nuanced work that gets better with every drawing you complete. The effort is worth it; you will learn to create drawings that are realistic, but also poetic.

For this step, have two dilutions prepared or use the dipping method: 1:6 dilution and 1:4 dilution. Carefully, study your reference image for areas that need more contrast or that require a bit of texture, still avoiding the white flowers and the vase. Use the 1:6 dilution for lighter areas that need texture or details and use the 1:4 dilution for areas of darkest contrast. As always, with such a small subject, use your most delicate touch with the pen and nib. See the example for an idea of how your drawing might look when this step is complete. Really get those darkest areas in place. This can be on the leaves or also on certain areas of the branches. Use stippling or other intuitive marks to create what your own eyes see. It's all about the dark and the light.

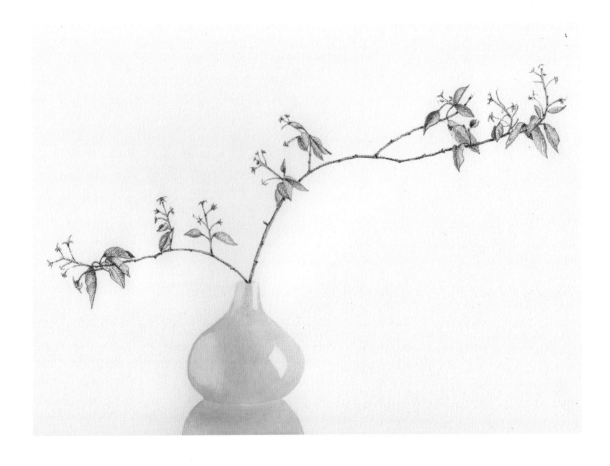

STEP SIX: THE WHITE FLOWERS AND FINISHING THE VASE

The final step for this project is adding the illusion of white flowers and adding contrast to the vase. For this, we will once again use a brush and a very diluted ink wash. The most important thing to remember is that you will be creating clusters of white flowers as seen in the reference, but that you will use your own artistic license about their placement. The main thing to notice is the shape of each petal and where it is dark and light. This step is done one petal at a time.

Make a 1:9 ink-to-water dilution and have a glass of clean water nearby. With the very pointed tip of a number 2 pointed round brush, create a water glaze in the shape of each petal, not too wet, just a smooth glaze of clear water in the shape of the petal as you see it. Good lighting really helps here. Once the glaze is down, dry your brush on a paper towel, dip the tip of it into your ink dilution, and then blot on the paper towel. Use the very tip of the brush to drop the ink into the petal where it's darkest. If it is too dark once

applied, wipe your brush clean and then blot up some of the ink to make it paler. Use your reference as a guide, but do not be afraid to improvise. If two petals touch one another, move to another area and paint that petal. You can go back to paint the petals that are touching when the first one is completely dry. Move around the entire drawing until all white flowers are complete. Then, use the pen and the diluted ink to add some details in the white flowers with tiny dots and lines, where you see the pistils and anthers. Study the sample drawing to see how this might look when finished.

For the vase, use the number 6 or 8 pointed round brush and the 1:6 ink-to-water dilution. Apply a light water glaze with clean water to the entire vase area. Dip the end of the brush into the ink dilution and then add a fine line of ink where you see the darkest area, where the vase meets the cast shadow. Right away, clean your brush and lightly dry it off and then soften the edges of the ink wash to let it blend into the cast shadow. Study the finished drawing to see how this should look.

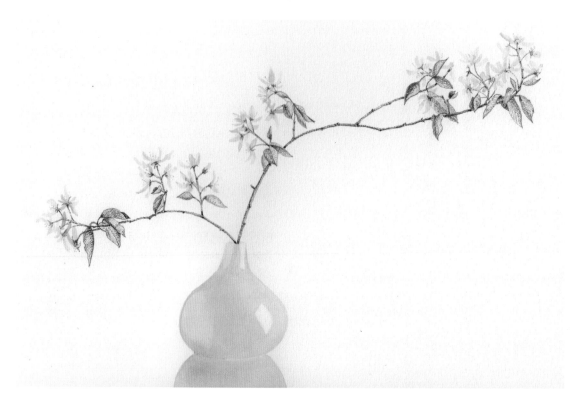

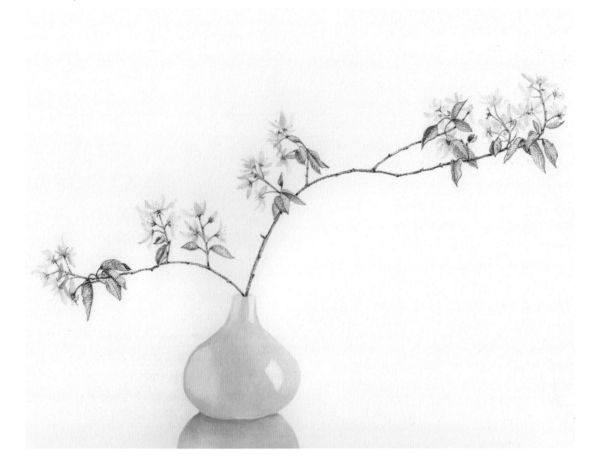

THE FINISHED DRAWING

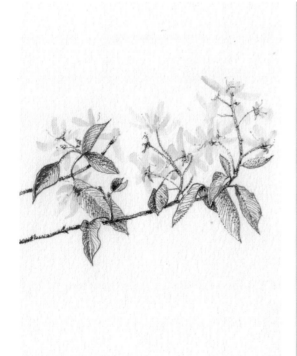

It's truly beneficial to experience the difference of creating drawings of the same subject with two vastly different mediums. It encourages us to see our subjects in terms of texture and contrast and form and to learn how to make decisions about how different subjects can be portrayed simply by our choice of tools and materials. I hope you will try this exercise with several different subjects and with all four mediums we've used in our lessons together. It will reinforce what your eyes see, instead of what your brain knows, and give you experience with your entire tool box. This is key to creating realistic drawings that are personal, unique to you, and filled with presence.

SOME FINAL THOUGHTS ON DRAWING

"I believe that the sight is a more important thing than the drawing . . .
I would rather teach drawing that my pupils may learn to love nature,
than teach the looking at nature that they may learn to draw."

John Ruskin

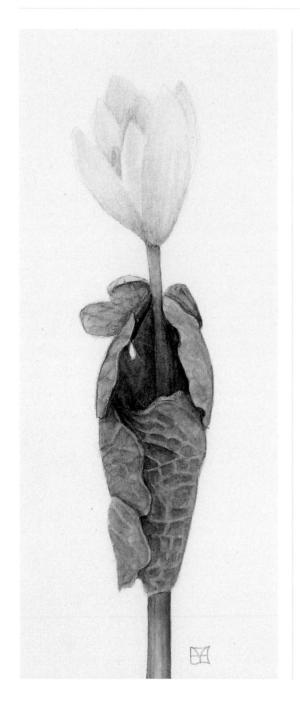

Bloodroot, watercolor and graphite

This quote from John Ruskin, the 19th century artist, writer, and philosopher, is why I draw and also why I aim to teach drawing to others. I draw to learn, to welcome the natural world around me into my life in a more meaningful way. I draw to find the extraordinary in the ordinary. All along the way, I have enjoyed the products of my eyes and hands and heart all working together: drawings in a realistic, yet poetic style that portray a sense of wonder and awe of the natural world.

Ruskin also wrote: "Your art is to be the praise of something that you love. It may only be the praise of a shell or a stone." This is my way. My art is to portray the world around me, the things that I love, on paper. In this book, I have shared with you techniques and thoughts about how I go about this way, in hopes that it might be your way, too. I also hope that you will find ways to share your own practice of drawing with others. It is my belief that the world would be a much more loving and peaceful, healthy place if more people took up a pencil, pen, charcoal stick, or brush to draw the world around them. Spread your love for drawing and spread it far and wide. Art is a way for us all.

Kateri Ewing
East Aurora, NY

Three Ladies, watercolor and graphite

Crow Fly, Be My Alibi, graphite and ink

Sapling, ink

Fallen Maple Leaf, graphite

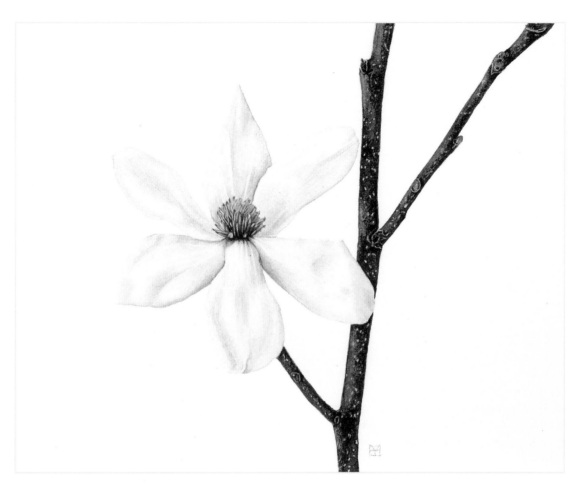

Magnolia, watercolor

Study for Knox Pines, graphite, charcoal, and watercolor

Three Pears, charcoal

Titmouse, graphite study for silverpoint

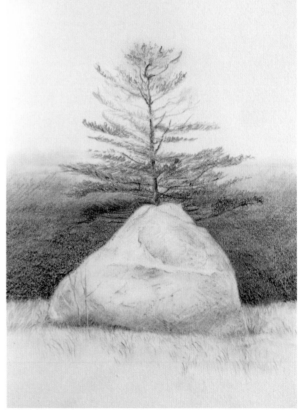

After Wyeth, charcoal and graphite

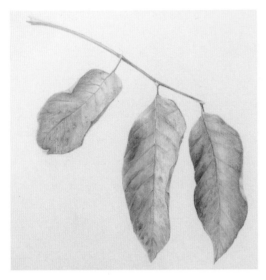

Three Leaves, graphite

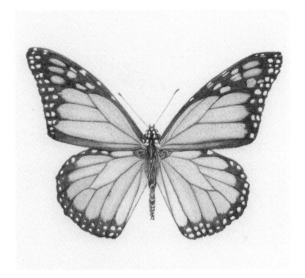

Monarch, watercolor

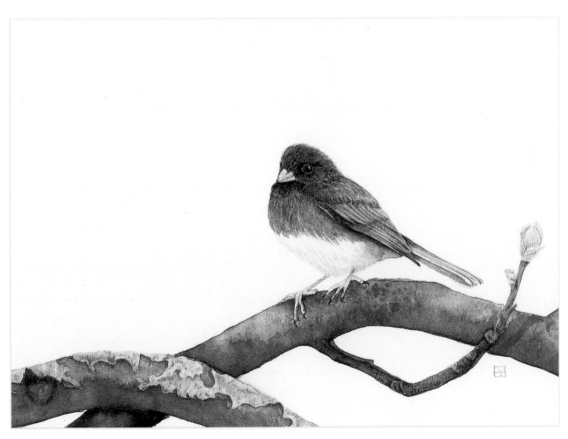

Junco or Branch, watercolor and graphite

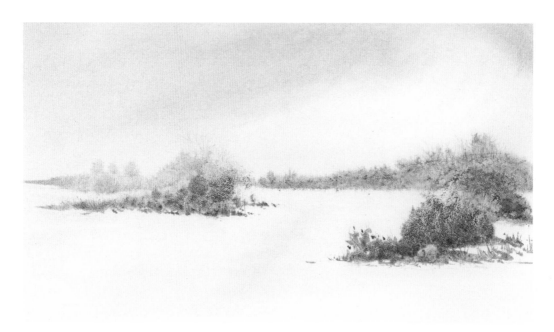

First Snow, ink and graphite

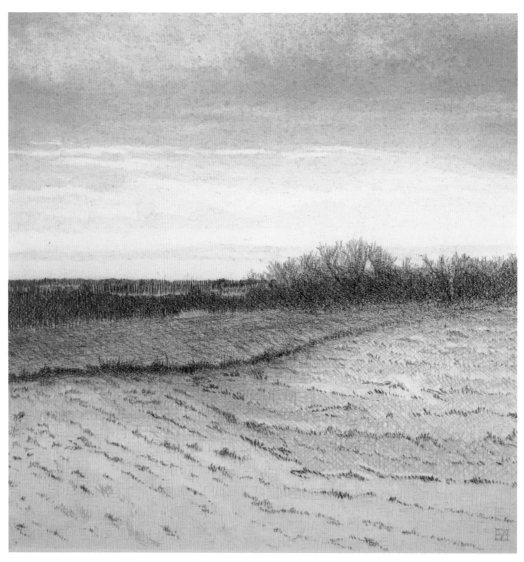

Van Gogh's Field, graphite and charcoal

Moonflower, charcoal

Missing You, graphite

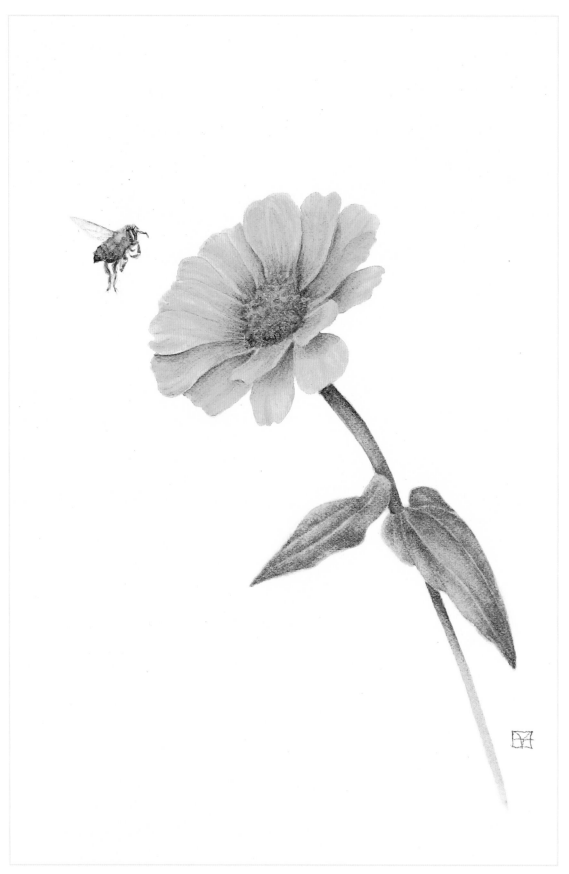

End of Summer's Dance, watercolor

Maple, watercolor

Sycamore, watercolor

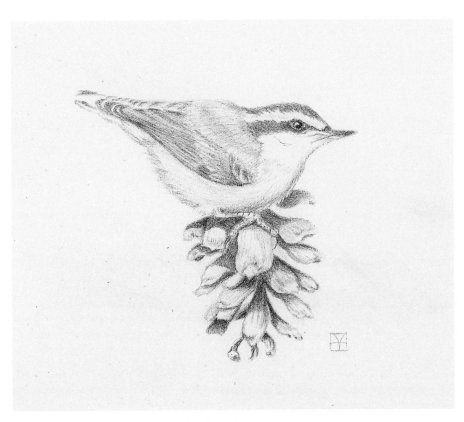

Red-Breasted Nuthatch, graphite study for silverpoint

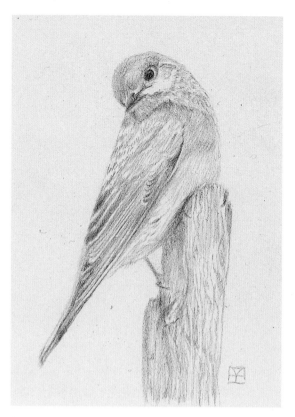

Sialis Sialis, graphite study for silverpoint

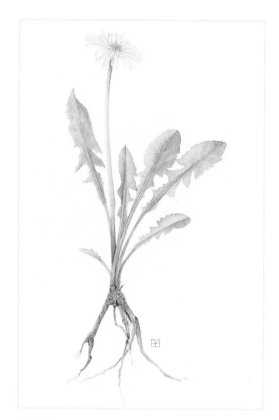

Dandelion, watercolor

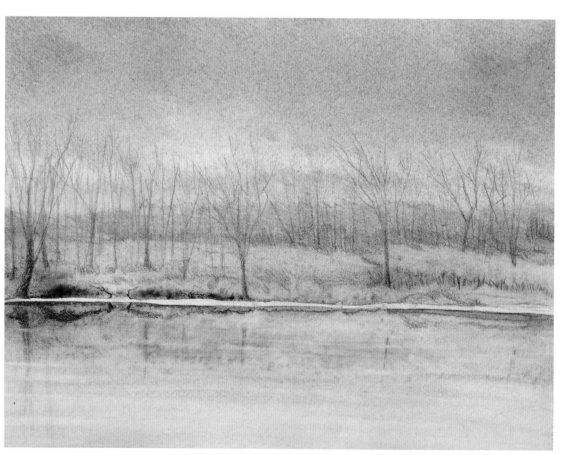

Thaw, ink and graphite

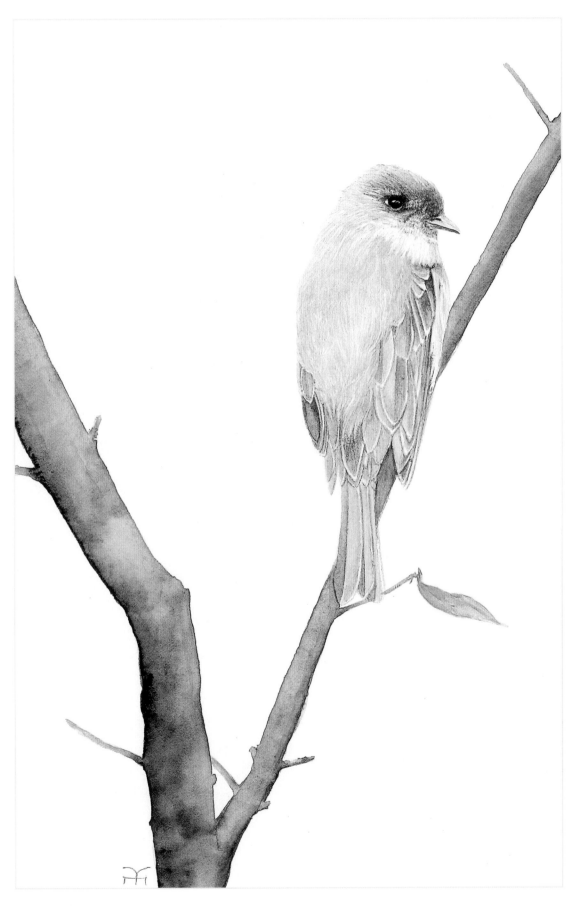

Phoebe, watercolor

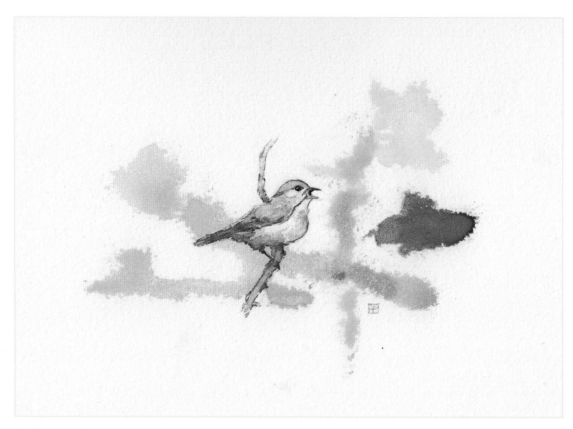

Bird Study, watercolor and ink

Flower Study, watercolor and graphite

RESOURCES

SOME BOOKS THAT I HAVE FOUND INDISPENSABLE AS AN ARTIST:

Andrew Wyeth: Master Drawings from the Artist's Collection by Henry Adams

Botany for the Artist by Sarah Simblett

The Elements of Drawing by John Ruskin

The Unknown Craftsman by Bernard Leach and Soetsu Yanagi

TOOLS AND MATERIALS:

All of the materials mentioned in this book can be purchased through online resources, or you can also check your local art supply stores. Here are some of my favorite online resources.

Blue Heron Arts Co.
Rowland Heights, CA
www.BlueHeronArts.com
Chinese art supplies

Earth Mineral Arts
Margot Guerrera
Santa Fe, NM
www.etsy.com/shop/EarthMineralArts
(Handcrafted watercolors)

Hyatt's Graphic Supply Co., Inc
Buffalo, NY
Hyatt's All Things Creative
www.hyatts.com
(General art supplies)

JetPens
San Jose, CA
JetPens.com
www.jetpens.com
(Great selection of inks, drawing nibs, and nib holders)

Rochester Art Supply
Rochester, NY
fineartstore.com
www.fineartstore.com
(All supplies, plus a fine selection of Chinese and Japanese art supplies)

Wildthorne
Aptos, CA
wildthorne.com
www.wildthorne.com
(Handcrafted gemstone and mineral watercolors)

I would also like to invite you to my YouTube channel, where you will find live demonstrations of many of the techniques found on this book.

www.youtube.com/user/kateriewing

Visit me at:
Website: www.kateriewing.com
Instagram: KateriEwingArt
Facebook: Kateri Ewing—Watercolours

ACKNOWLEDGMENTS

How can I fit a lifetime of thank-yous into one small space? So many people, even some I've never met, have helped me find my way to where I sit right now. Here are a few that I wish I could gather around an enormous table for a warm celebration of gratitude.

My mom, Kateri; my dad, Donald; my stepmom, Diane; my brother Michael, for being my family, the people who are always there for me, through thick and thin, and who have encouraged me to follow my own path. I love you all far more than I can express.

My children, Kristoffer and Anna, for being my constant true north, my reason for pushing through the hardest times, my forever cheering section. You are my greatest treasures and most beloved. I am so proud of you both.

My sweetheart, Rick, my best friend in the whole world, my fellow artist who understands the path and walks along beside me. It is an immense gift to share my life with someone who appreciates the work I do every day, and every day also celebrates my efforts, achievements, and helps me remember that my failures are what help me grow, with such steadfast love and compassion. I am truly, really truly, the most grateful and lucky woman. I never knew this kind of love, until I knew you. I could not do the work, the way I need to do the work, without you by my side.

My stepdaughter, Mariah, for also being my cheerleader, and for your love and acceptance of me in your life. I'm so grateful for you.

My dearest girlfriends, who have lifted me up when I really needed the lifting. You've been the most understanding and supportive friends a woman could ever hope for. Thank you, for everything, always.

My friend, Grace Meibohm, owner of Meibohm Fine Arts, and her staff David, Mark, and Nancy, who have become like family to me. Thank you for seeing in me what I could not see for myself. Thank you for every opportunity, for your nurturing kindness, for believing in me. How can I ever say thank you enough?

My team, past and present, at Craftsy, for all you have made possible for me by giving me a chance and treating me like a queen. I've learned so much, and I am so grateful.

My editor, Judith Cressy, for your vision of this book, for believing I had it in me, for your guidance and patience and kindness all along the way. I'm still amazed that you gave me this opportunity. Thank you, always.

My students, the ones who encourage me to share my love for drawing and my deep belief in the power of the creative practice. It is my honor to share it all with you. Thank you for giving me the gift of seeing things through your eyes, as I continue to practice the gift of seeing through my own. We are, all of us, eternal beginners . . . the most wonderful thing to be.

And to my greatest teachers, John Ruskin and Andrew Wyeth, whose life's work and words have been a never-ending fount of inspiration and wisdom.

ABOUT THE AUTHOR

Kateri Ewing says that her work isn't so much about creating art or making a statement as it is an avenue to convey how thoroughly in awe she is of the natural world around her. She expresses that awe in richly detailed drawings and paintings of songbirds and treasures of the plant kingdom. Self-taught and committed to her continuing development as an artist, her technique evolves as she imagines ways to share the beauty and uniqueness of her winged and botanical subjects.

Kateri has lived in western New York for more than half her life and counts Europe, the Midwest, the Desert Southwest, and Texas as previous homes. In preparation for drawing and painting, she regularly walks, sketches, and photographs the woods, meadows, and waterways near her home. She lives with her sweetheart, Rick Ohler, at Three Cat Farm, where they happily work side by side on all of their creative endeavors. She teaches at her studio at the historic Roycroft Campus, as well as for Craftsy.com, NBC/Universal's Bluprint.com, and at workshops near and far. Kateri is also a Companion of the Guild of St. George. Visit her online at www.kateriewing.com.

Brimming with creative inspiration, how-to projects, and useful information to enrich your everyday life, Quarto Knows is a favorite destination for those pursuing their interests and passions. Visit our site and dig deeper with our books into your area of interest: Quarto Creates, Quarto Cooks, Quarto Homes, Quarto Lives, Quarto Drives, Quarto Explores, Quarto Gifts, or Quarto Kids.

© 2019 Quarto Publishing Group USA Inc.
Text, illustrations, and photos © 2019 Kateri Ewing

First published in 2019 by Rockport Publishers, an imprint of The Quarto Group, 100 Cummings Center, Suite 265-D, Beverly, MA 01915, USA.
T (978) 282-9590 F (978) 283-2742 QuartoKnows.com

All rights reserved. No part of this book may be reproduced in any form without written permission of the copyright owners. All images in this book have been reproduced with the knowledge and prior consent of the artists concerned, and no responsibility is accepted by producer, publisher, or printer for any infringement of copyright or otherwise, arising from the contents of this publication. Every effort has been made to ensure that credits accurately comply with information supplied. We apologize for any inaccuracies that may have occurred and will resolve inaccurate or missing information in a subsequent reprinting of the book.

Rockport Publishers titles are also available at discount for retail, wholesale, promotional, and bulk purchase. For details, contact the Special Sales Manager by email at specialsales@quarto.com or by mail at The Quarto Group, Attn: Special Sales Manager, 100 Cummings Center, Suite 265-D, Beverly, MA 01915, USA.

10 9 8 7 6 5 4 3 2 1

ISBN: 978-1-63159-622-3

Digital edition published in 2019
eISBN: 978-1-63159-623-0

Library of Congress Cataloging-in-Publication Data available.

Cover Images: Kateri Ewing
Design and Page Layout: Allison Meierding
Photography: Kateri Ewing; Shutterstock on pages 22, 29 (bottom), 38, 47 (bottom), 56 (top), 76, 81 (bottom), 82 (top), 87 (top), 88, 95 (bottom), and 96; and Mark Strong, Meibohm Fine Arts on pages 2, 4, 16, 48, 62, 113, 114, 116, 120, 121, and 122.
Illustration: Kateri Ewing

Printed in China